TEMARI
TREASURES
JAPANESE THREAD BALLS AND MORE

DIANA VANDERVOORT

JAPAN PUBLICATIONS TRADING COMPANY

Published by JAPAN PUBLICATIONS TRADING CO., LTD.,
1-2-1 Sarugaku-cho, Chiyoda-ku, Tokyo, 101-0064 Japan

First edition, First printing: December 1996
 Second printing: May 1998

Distributors:

UNITED STATES: *Kodansha America, Inc. through Oxford University Press,*
 198 Madison Avenue, New York, N.Y. 10016.
CANADA: *Fitzhenry & Whiteside Ltd., 195 Allstate Parkway, Markham,*
 Ontario L3R 4T8.
UNITED KINGDOM and EUROPE: *Premier Book Marketing Ltd., 1 Gower Street,*
 London WC1E 6HA, England.
AUSTRALIA and NEW ZEALAND: *Bookwise International, 54 Crittenden Road,*
 Findon, South Australia 5023, Australia.
THE FAR EAST and JAPAN: *Japan Publications Trading Co., Ltd.,*
 1-2-1 Sarugaku-cho, Chiyoda-ku, Tokyo, 101-0064 Japan.

10 9 8 7 6 5 4 3 2

ISBN 0-87040-983-2

Printed in Japan

CONTENTS

List of Illustrations

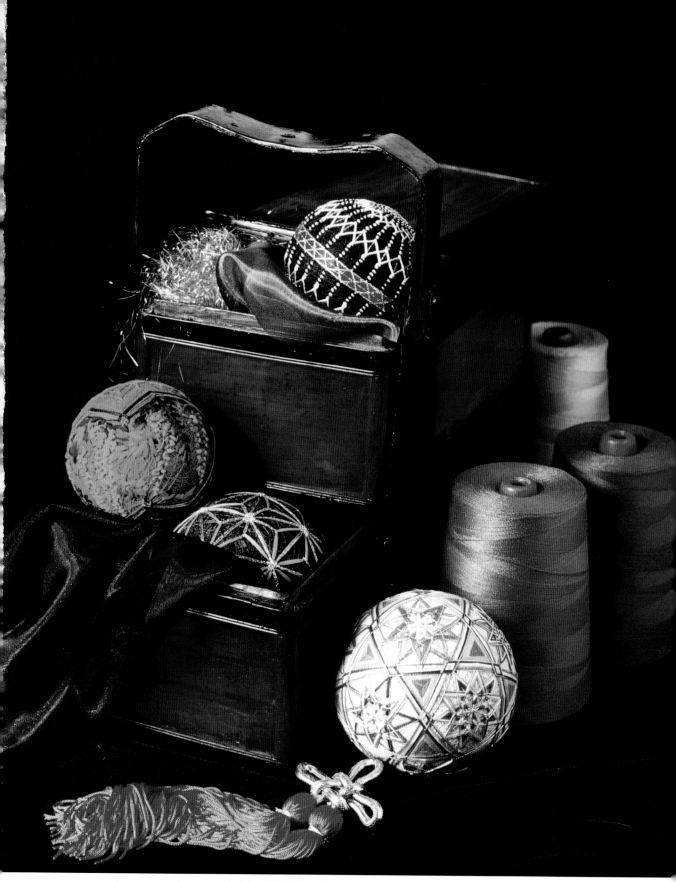

from top to bottom : **Spider Web Dewdrops** (p. 52), **Wisteria** (p. 49),
Crystal Star (p. 93), **Flaming Pearl** (p. 101).

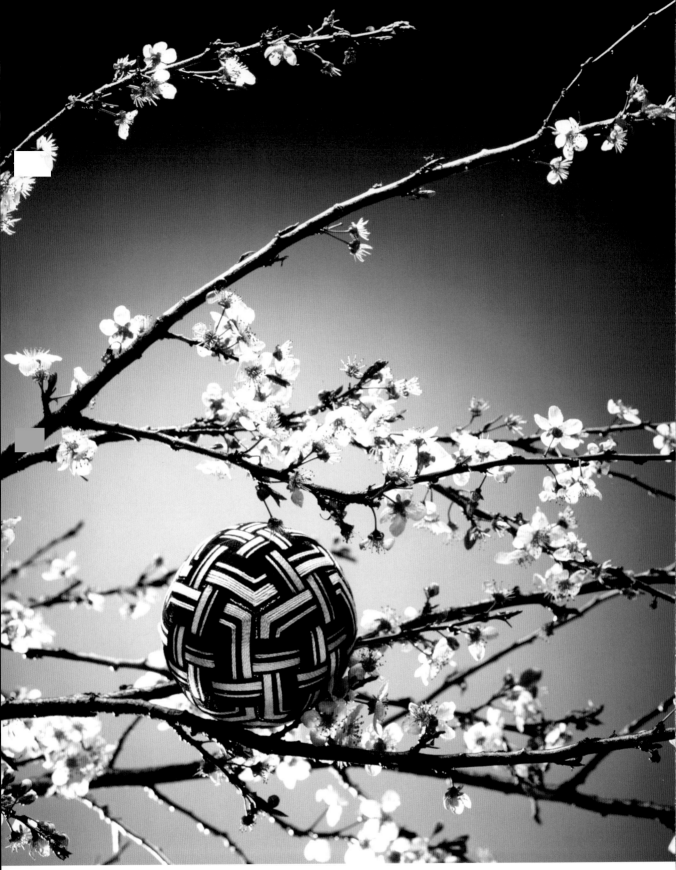

Square Dance (p. 67).

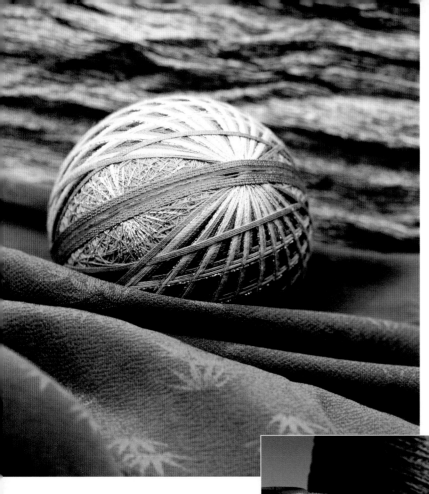

The Wave (p. 29).

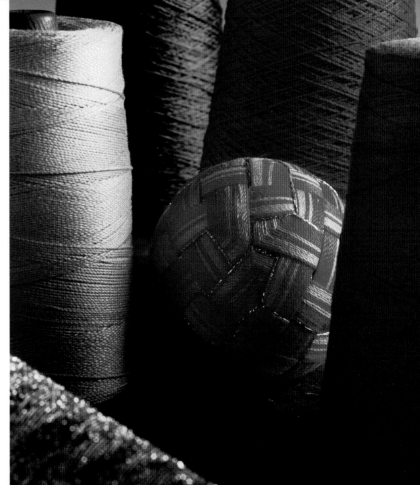

Square Dance (p. 67).

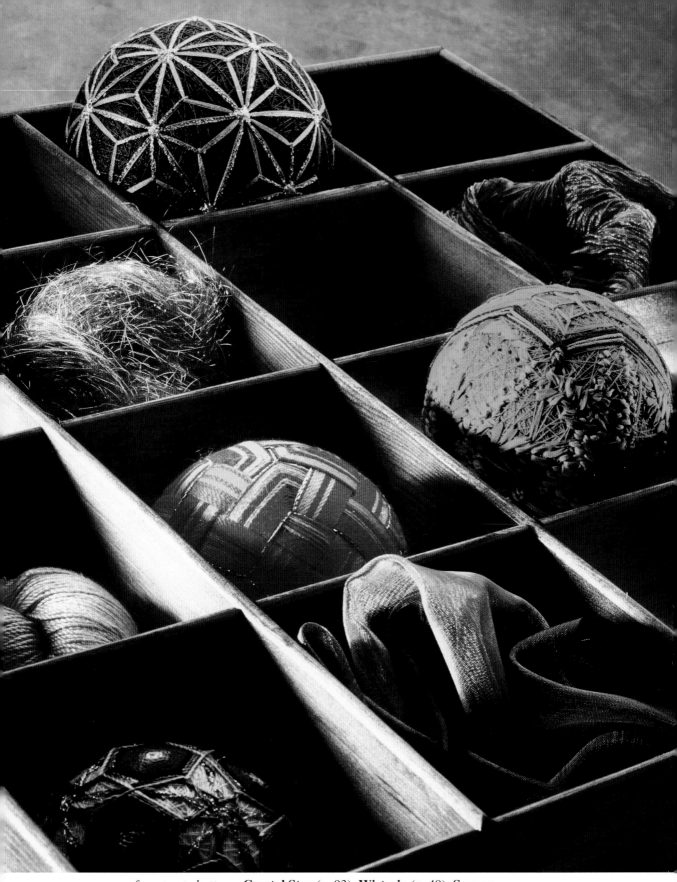

from top to bottom : **Crystal Star** (p. 93), **Wisteria** (p. 49), **Square Dance** (p. 67), **Morning Glories** (p. 87).

8

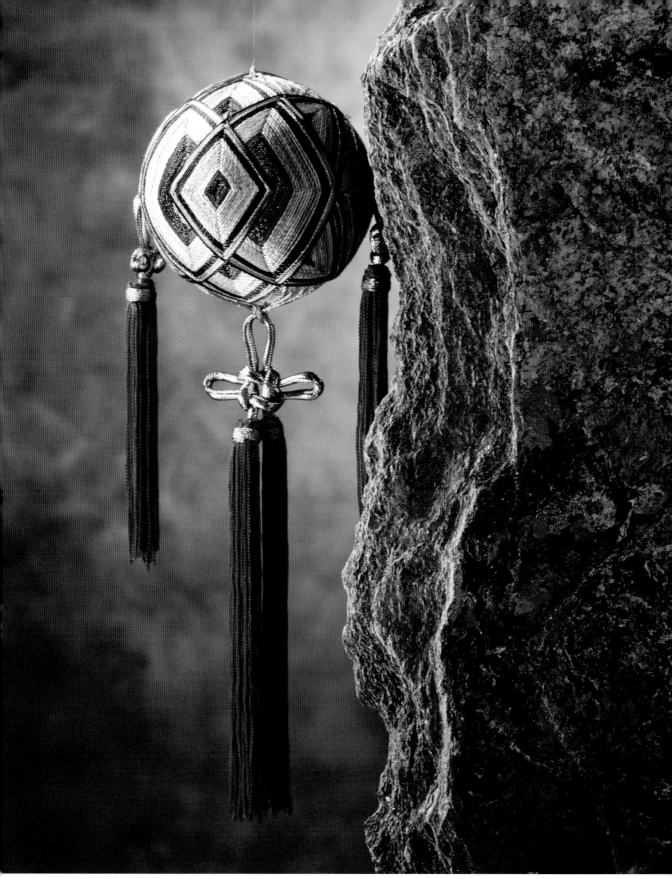

Intrigue (p. 61).

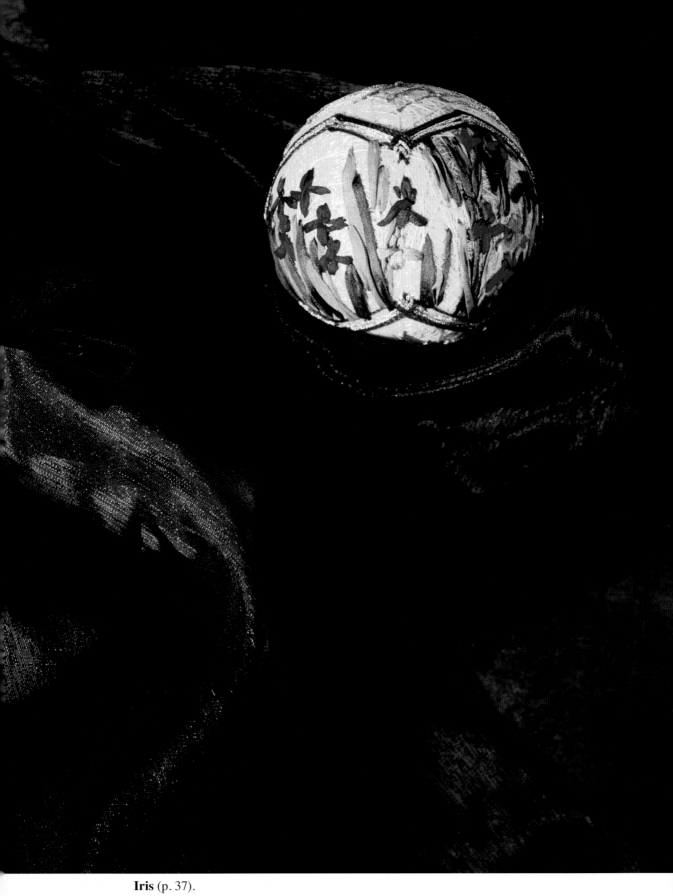

Iris (p. 37).

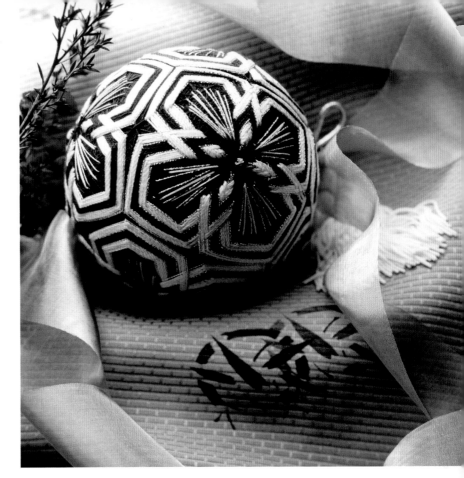

Winter Pines (p. 77).

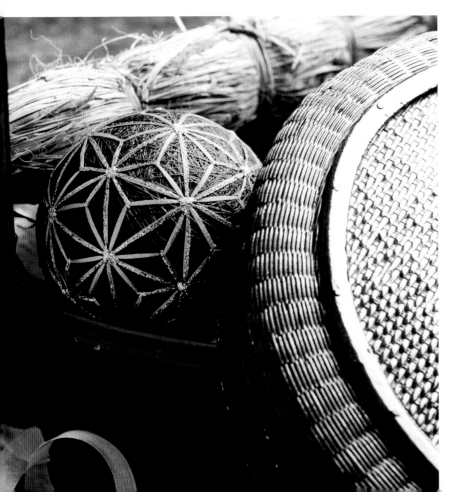

11

Crystal Star (p. 93).

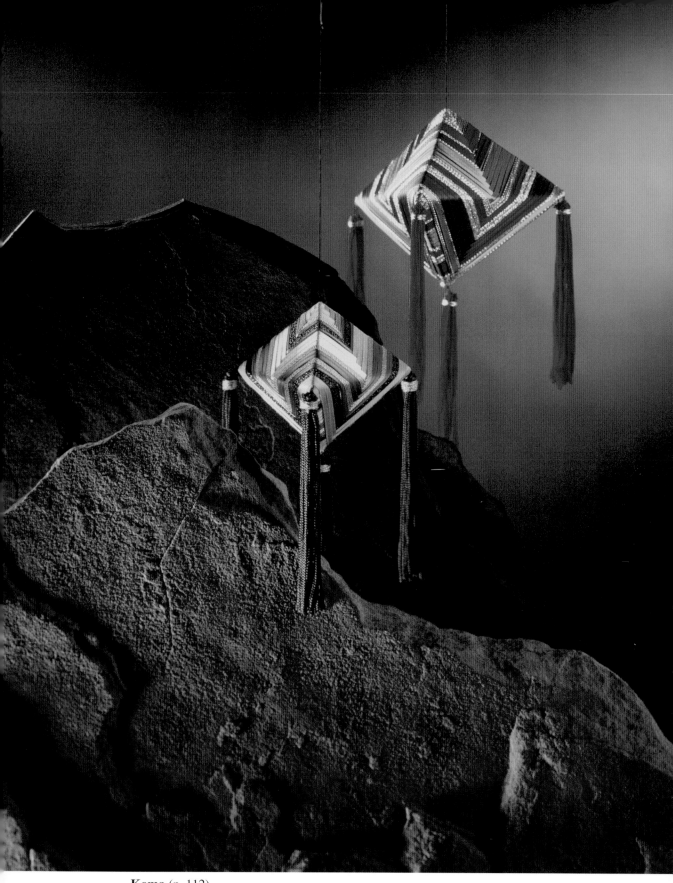

Koma (p. 112)

PREFACE

Temari, Japanese thread balls, are a new world of adventure for fiber artists, needle crafters and designers. Temari brings with it the thrill of discovery and the joy of accomplishment because *everyone can do it*. Completely unique, it is one of the most satisfying, soothing, yet profoundly fascinating needle crafts currently known. Temari offers constant adventures, new discoveries, excitement and suspense as designs bloom and change.

Elegantly simple methods and techniques make it easy enough for everyone to achieve exquisite results. Clear pathways are marked by numbered label pins. Follow the numbers and watch the design develop itself right before your eyes. Directions: Top—North Pole, Bottom—South Pole, and Middle—Equator, are all marked with colored marker pins to lead the way. Clear diagrams and instructions guide easily through every step of the pattern. Intricate kaleidoscopic designs that look incomprehensible are merely rhythmic patterns of numbers and colors.

Tantalizing with a myriad of colors, glittering fibers and materials of every kind and hue, infinite combinations and astounding patterns drive the crafter to explore, experiment and invent endless new possibilities.

TEMARI TREASURES: Japanese Thread Balls and More, book three in the series, continues the ancient traditional art form with nine more intermediate patterns, bringing more new tricks and techniques of fascination and fun, more new methods and materials.

All of the balls are traditional temari designs except for the two of silk ribbon embroidery. This old technique in new combination worked so well that it just had to be shared. The silk ribbon technique becomes similar to *sumi-e,* Japanese brush painting techniques. One stroke creates a leaf, or a flower. One stitch, with a twist of the ribbon, creates a stem or a petal. The surface of the ball cooperates perfectly by holding the stitch in place exactly as it was laid down.

In addition to the nine balls, this book includes another ornament similar in feeling to *temari* called a *koma,* a child's toy spinning top. It is a wrapped ornament using a simple double-pyramid cardboard form. This project is easy enough for children to accomplish and achieve wonderful results and they love it!

Tassels became a chapter of the book in order to complete the *koma.* Very simple tassels made from decorative upholstery fringe are included for smaller balls and *koma.* And a formal temari would not be complete without the elegant dragonfly knot tassel, which is included to elaborate on the tradition.

The custom of temari comes from re-using the materials at hand, discarded in one form because they are well used and worn, no longer able to serve their original purpose after a long life. With the creation of a temari, the materials were regenerated into another form, reborn into an exquisite symbol of love, esteem and honor, a glowing tribute to the recipient.

Early temari were made of the unraveled threads of discarded silk kimonos. Around a core of wadded fabric, rice hulls, or paper, threads were wrapped so tightly that the balls would actually bounce for children's games.

The warm and happy traditions of family and home always include the joy of giving a very special gift from the heart. It is a universal combination the same the world over. Temari are treasures of tradition—like inter—cultural gifts of joy from the households of Japan to be enjoyed and cherished in the households of the world.

Thanks be given to the lovely inventors of this very special tradition. They are our real treasures, the mothers and grandmothers who, through the ages and throughout every region of Japan, wrapped these toy balls for their young children to enjoy in play, honing their skills with every new pattern, creating more and more, one from another, to give us today this stately art form of elegance and formality.

GLOSSARY OF MATERIALS

All of the materials selected for use in this book have been chosen for their accessibility. In some cases, brand names have been suggested in order to more specifically describe a material. In the case of the Pearl Cotton #5, DMC has been named exclusively for the projects in this book, however other brands such as Anchor will perform equally. For all of the materials listed, a generic description is provided for clarification as well as the type of shop where the material can be purchased.

Styrofoam Balls and Eggs found in hobby or craft stores, the measurement size refers to the diameter of the ball, i.e., a 3-inch ball measures 3 inches through the center of the ball, not around the outside of the ball. The measurement of the egg is from top to bottom through its center, not around the outside. Check each Styrofoam blank carefully before you buy for dents or flat spots on the surface; these make dividing the ball difficult.

Polyester Batting also called Fleece—found in fabric stores, is 1/4 to 3/8 inch or 1/2 to 1 centimeter thick. It is commonly used for trapunto and applique, has low loft with consistent texture and thickness throughout. Batting can be purchased by the yard from a bolt or pre-cut in a plastic bag.

The Yarn Wrap look in your craft store for spools of mini-punch needle yarns, some are called "Purrfect Punch." A wide range of colors are available. Baby, sock or sport weight yarn of consistent texture works well. Finer, light weight yarns are preferable. Heavier weight yarns create lumps on the ball's surface. The yarn's color should be a similar color to the outer thread wrap.

The Thread Wrap—regular sewing thread, polyester or cotton, is the outer thread wrap. Select your Pearl Cotton #5 decorative threads first, then match the sewing thread to them. 200 yards cover a 3-inch ball (1 medium spool or 2 small spools). A 4-inch ball takes 1 large spool, or 1 medium spool plus 1 small spool.

Needles—temari requires a long sharp needle with a large eye. Cotton or Yarn Darners (2 1/2 inches long), size #18, may be found in fabric and needle craft stores. One shorter yarn needle is helpful in your pincushion to anchor the yarn-wrap end.

Colored Glass-headed Pins should be 1 to 1 1/4 inches in length. A variety of 6 to 8 colors is helpful; purchased in fabric or craft stores.

Red Tomato Pin Cushion—to hold glass-headed pins separated by color.

Fabric Shears—for cutting polyester batting for balls and felt for eggs, the sharper the better.

Thread Scissors—small needlework scissors with sharp points for cutting single threads.

Centimeter Tape Measure—the common wind-up variety that measures 150 centimeters on one side of the tape and 60 inches on the backside. The narrower the better.

Measuring Papers — copier paper (20 pound bond) cut on a paper cutter works great. Letter size (8 1/2 by 11) measures a 3-inch ball, legal size (8 1/2 by 14) measures a 4-inch ball. Cut paper into strips lengthwise, 3/8 inch or 1 centimeter wide.

Paper Tabs can be cut from Measuring Papers, 1 1/2 inches long by 3/8 inches wide (3.5 cm by 1 cm). Round the corners with your scissors.

Gold and Silver Metallic Marking Thread — generically called "knitting metallics" or "needlepoint/stitchery metallics," can be found in needle craft stores, larger yarn and craft shops. They should be 6 strands, twisted or braided — not chained or wrapped. Kreinik's Balger Ombre, Japan Braid #4 and #8, Cord and Ribbon produce excellent results. Colors and variety are exceptional. Kreinik Mfg. Co., P. O. box 1966, Parkersburg, WV 26101.

Surface Decoration Threads — Pearl Cotton #5 weight. DMC and Anchor are commonly accessible, have a huge variety of hues and shades and provide ease in keying colors and shades. Two skeins approximately equal one ball. Prepare skeined threads by wrapping around a cardboard card 2 by 3 inches. Write the color number and manufacturer's name on the card for future reference.

Felt Squares, in colors to match your Faberge Egg project, measure one foot square. They can be found in fabric and craft stores. For the Faberge Eggs, felt replaces the batting, yarn, and thread wrap layers of temari preparation. It provides a refined surface to stitch into and a colored background behind the surface cover threads.

Other Materials to Try:

"Bunka" Japanese Rayon Chainette made by KAO Brand (color numbers used are from KAO Brand Bunka color card). When unchained or pulled out, it produces a finer gauge, non-stretch, crepe-like texture. In its pulled-out state, it is called "Rydian." It has a beautiful range of very typical Japanese colors, keyed for combinations, from vivid brilliants to subtle neutrals (called "Shibui"). Dampen it slightly to remove the kinks. A favorite temari material in Japan — but watch out, it fades. Order KAO Brand from "Lacis," 3163 Adeline St., Berkeley, CA 94703.

Y. L. I. Silk Ribbons come in a wonderful variety of shades and widths and can be commonly found in larger craft stores. Color numbers in the silk ribbon patterns are from Y. L. I. charts. A range of color-keyed Bunka and Silk Threads is also available, matched to the silk ribbon colors! Y. L. I. Corp., P. O. Box 109, Provo, UT 84601 (801)377-3900.

Brazilian Embroidery Threads can be used for stitched patterns only. Because they are rayon, they are too slick for wrapped designs. They provide a beautiful array of colors and a very formal, polished, silky sheen. Order from Edmar Co., P. O. Box 55, Camarillo, CA 93011.

The Caron Collection — "Watercolors" and "Waterlilies" are hand-painted cotton and wool. "Watercolors" 3 plies, when separated, equal 1 strand of Pearl Cotton #5. The Caron Collection, 67 Poland Street, Bridgeport, CT 06605.

Needle Necessities has overdyed and shadow-dyed fibers of all types in exquisite colors. 14746 N.E. 95th St., Redmond, WA 98052.

Rhode Island Textiles produces RibbonFloss™, a bias-woven rayon about 1/16 inch wide an a beautiful range of colors, and Reflections™, metallics that work well together. RibbonFloss™ has a

formal glossy look that is very striking. Rhode Island Textile Co., P. O. Box 999, Pawtucket, RI 02862, or Nancy's Notions – Beaver Dam, WI, (414) 887-0391, or Leisure Arts – Little Rock AR, (501) 868-8800.

Madeira Threads have a vast array of everything from 6-strand floss in terrific pull-out packages to rayons and very unique metallics. Contact S.C.S. U. S. A., 9631 Northeast Colfax St., Portland, OR 97220-1232.

Sweet Child of Mine has "Petals," a collection of over-dyed Silk Ribbons and matching 6-strand silk threads by Rajmahal. Ribbon is by Y. L. I. In 4 and 7 mm. Variegated colors and color variety packs cover the whole spectrum. Sweet Child of Mine, 139 East Fremont Ave., Sunnyvale, CA 94087.

Renaissance Threads has another lovely collection of possibilities including "Shimmer," "Moonglow," "Ultrasprinkles" and "Pizzaz." Beautiful Combinations of rayons in brilliant colors spun with pearls or metallics. Renaissance Designs, 15 Rogers Rd., Far Hills, NJ 07931.

The Magic Needle has a variety of silk ribbons and synthetic or protein fiber embroidery ribbons, near to silk but lower in price. The Magic Needle, RR2, Box 172, Limerick, ME 04048.

Any of the suggested threads above can be substituted for colors and fibers mentioned in the patterns. I list these alternatives to provide an even broader range of possibilities for your creativity and enjoyment. Look for them in your retail store. Try them and enjoy!

GLOSSARY OF SYMBOLS

Fig. 1

NORTH POLE

OBI=EQUATOR

SOUTH POLE

Fig. 2

MARKING PINS

WHITE=NORTH POLE

BLACK=SOUTH POLE

Fig. 3

<TOP VIEW>

OBI

Fig. 4

<SIDE VIEW>

OBI

Fig. 5

PAPER MEASURE

Fig. 6

MEASURE the BALL.
MARK with PINS.

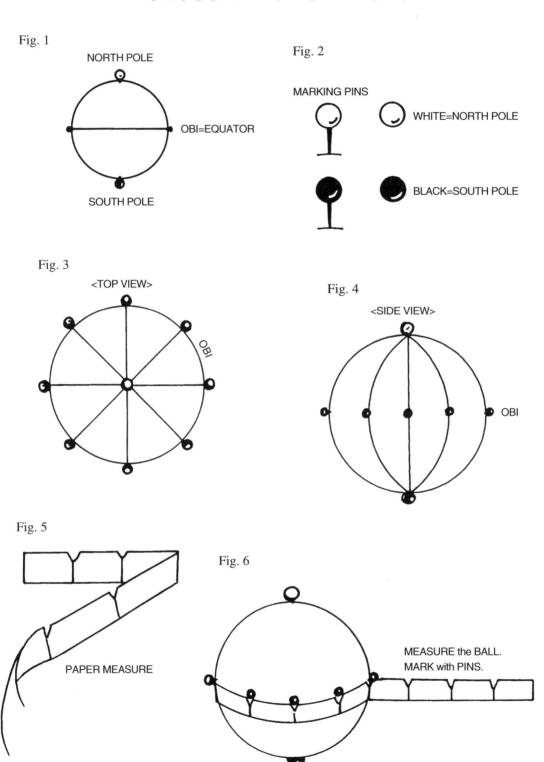

Fig. 7

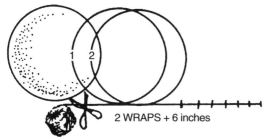

2 WRAPS + 6 inches

MEASURE the THREAD by WRAPPING IT
AROUND the BALL.

Fig. 8

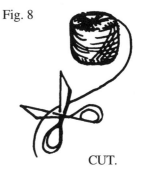

CUT.

Fig. 9

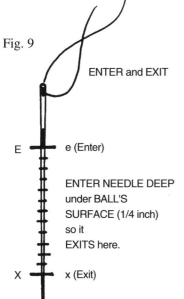

ENTER and EXIT

E — e (Enter)

ENTER NEEDLE DEEP
under BALL'S
SURFACE (1/4 inch)
so it
EXITS here.

X — x (Exit)

ESCAPE:
PULL NEEDLE and THREAD
THROUGH BALL. CUT THREAD
at BALL'S SURFACE.

Fig. 10

WRAP or PROCEED in DIRECTION
of the ARROWS.

Fig. 11

USE PINS to ALIGN THREADS.

PIVOT THREADS around the PIN.

Fig. 12

TACK INTERSECTIONS of MARK THREADS.

19

Fig. 13

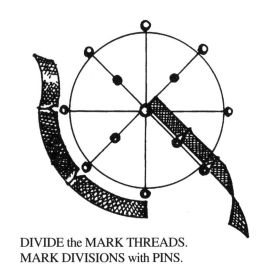

DIVIDE the MARK THREADS.
MARK DIVISIONS with PINS.

Fig. 14

NORTH

DIVIDE with
PAPER MEASURE.
MARK with PINS.

1/2

1/2

OBI

Fig. 15

PAPER TAB

SLIDE PAPER TAB under PATTERN
THREADS.
PUSH NEEDLE, EYE-END FIRST,
between TAB and THREADS.

Fig. 17

THREAD NEEDLE

DO NOT CUT THREAD
from BALL.

Fig. 16

KEEPER PINS

INSERT SIDE by SIDE,
CLOSE TOGETHER, at OBI LINE.

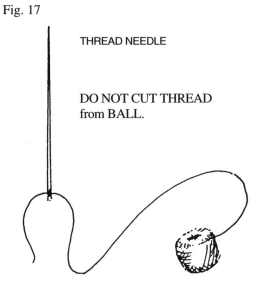

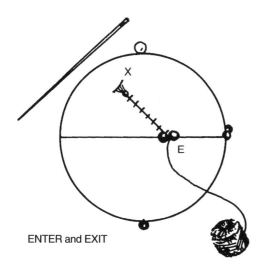

Fig. 18

X

E

ENTER and EXIT

REMOVE NEEDLE from THREAD.
PULL THREAD'S END under BALL'S
SURFACE.

Fig. 19

THREAD 2 NEEDLES
with 2 COLORS
to ALTERNATE QUICKLY.

The Division Symbols

DIVIDE and MARK the BALL into:

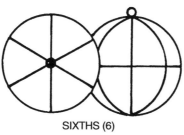

Fig. 20

SIXTHS (6)

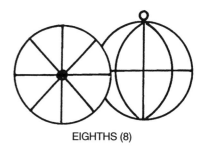

Fig. 21

EIGHTHS (8)

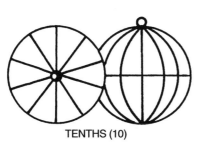

Fig. 22

TENTHS (10)

Fig. 23

DOUBLE EIGHTHS

Fig. 24

PENTAGONS

WRAP THE BALL

METHOD: THE BATTING LAYER

Fig. 1

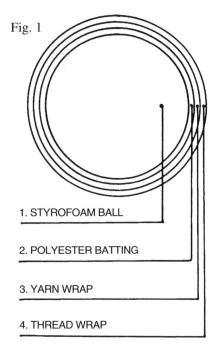

1. STYROFOAM BALL

2. POLYESTER BATTING

3. YARN WRAP

4. THREAD WRAP

CUT 2 RECTANGLES OF BATTING.

Fig. 2

for 3 inch ball

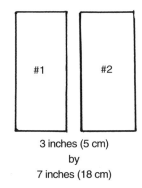

3 inches (5 cm)
by
7 inches (18 cm)

Fig. 3

for 4 inch ball

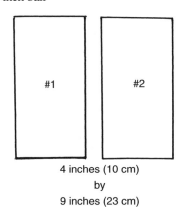

4 inches (10 cm)
by
9 inches (23 cm)

Fig. 4

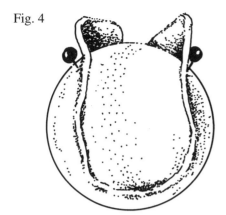

Lay on batting
Rectangle #1.
PIN ENDS to ball.

Fig. 5

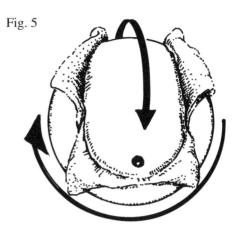

Lay on batting
Rectangle #2 crosswise.
PIN ENDS to ball.

Fig. 6

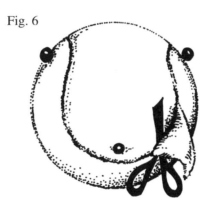

TRIM off corners
and excess to fit
precisely.

**RANDOM WRAP THE YARN LAYER.
REMOVE THE PINS.**

Fig. 7

RANDOM WRAP
THE THREAD LAYER.

Fig. 8

TO FINISH:
THREAD END into NEEDLE.
STITCH into BALL.
CUT at BALL'S SURFACE.

DIVIDE THE BALL

THE NORTH POLE

PAPER MEASURE:
Fold 1/4 inch from end. Pin fold.

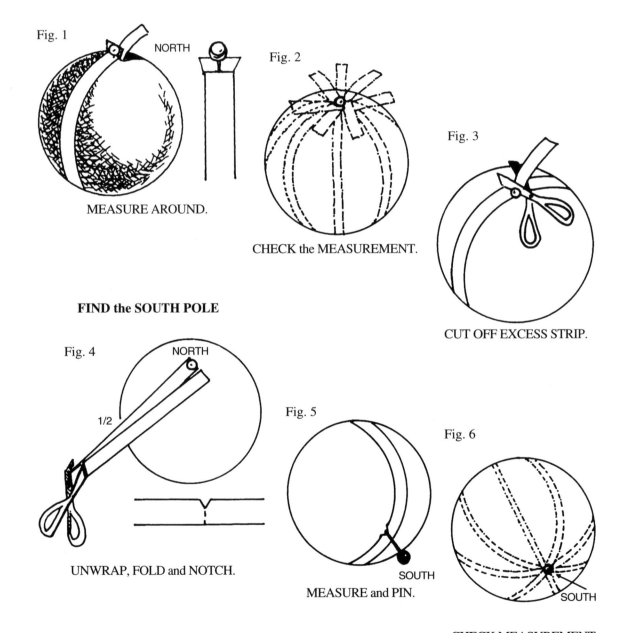

Fig. 1

NORTH

MEASURE AROUND.

Fig. 2

CHECK the MEASUREMENT.

Fig. 3

CUT OFF EXCESS STRIP.

FIND the SOUTH POLE

Fig. 4

NORTH

1/2

UNWRAP, FOLD and NOTCH.

Fig. 5

SOUTH

MEASURE and PIN.

Fig. 6

SOUTH

CHECK MEASUREMENT
and CENTER the PIN.

FIND THE OBI LINE

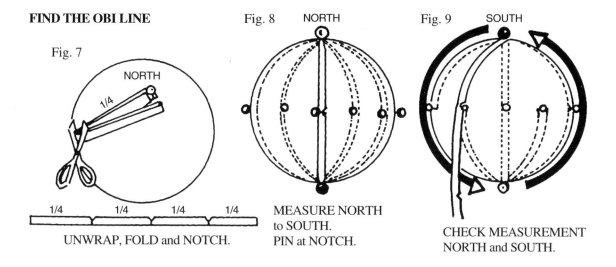

Fig. 7

NORTH

1/4

| 1/4 | 1/4 | 1/4 | 1/4 |

UNWRAP, FOLD and NOTCH.

Fig. 8 NORTH

MEASURE NORTH
to SOUTH.
PIN at NOTCH.

Fig. 9 SOUTH

CHECK MEASUREMENT
NORTH and SOUTH.

TO FIND 8 DIVISIONS AROUND THE OBI LINE

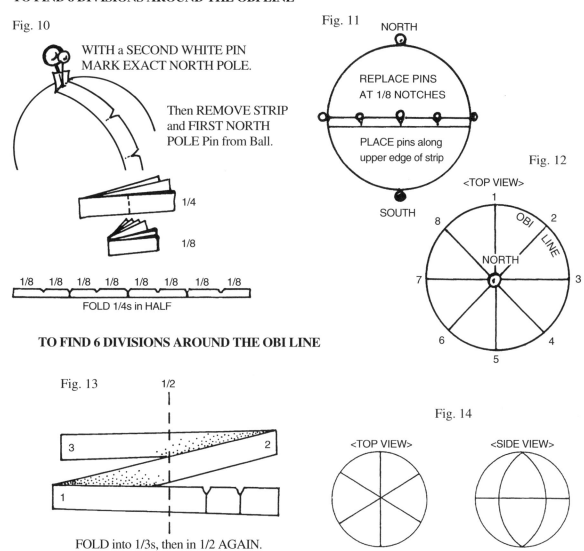

Fig. 10

WITH a SECOND WHITE PIN
MARK EXACT NORTH POLE.

Then REMOVE STRIP
and FIRST NORTH
POLE Pin from Ball.

1/4

1/8

| 1/8 | 1/8 | 1/8 | 1/8 | 1/8 | 1/8 | 1/8 | 1/8 |

FOLD 1/4s in HALF

Fig. 11 NORTH

REPLACE PINS
AT 1/8 NOTCHES

PLACE pins along
upper edge of strip

SOUTH

Fig. 12

<TOP VIEW>

1
8 OBI 2
 LINE
7 NORTH 3
6 4
5

TO FIND 6 DIVISIONS AROUND THE OBI LINE

Fig. 13 1/2

3 2

1

FOLD into 1/3s, then in 1/2 AGAIN.

Fig. 14

<TOP VIEW> <SIDE VIEW>

MARK THE BALL

METHOD: FOR 8 DIVISIONS

Fig. 1

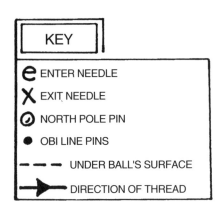

KEY

e ENTER NEEDLE
X EXIT NEEDLE
⊘ NORTH POLE PIN
● OBI LINE PINS
– – – UNDER BALL'S SURFACE
▶ DIRECTION OF THREAD

Fig. 2

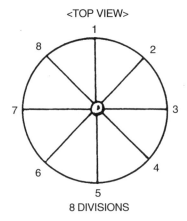

\<TOP VIEW\>

8 DIVISIONS

Fig. 3

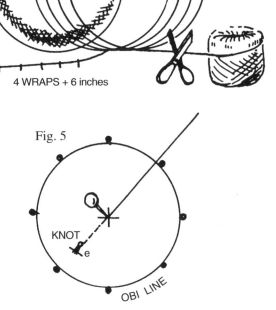

MEASURE MARKING THREAD

4 WRAPS + 6 inches

Fig. 4

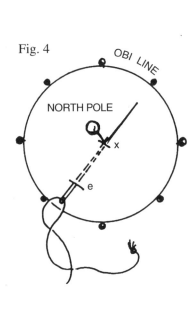

OBI LINE

NORTH POLE

x

e

Fig. 5

KNOT

e

OBI LINE

PULL THREAD END UNDER SURFACE.

26

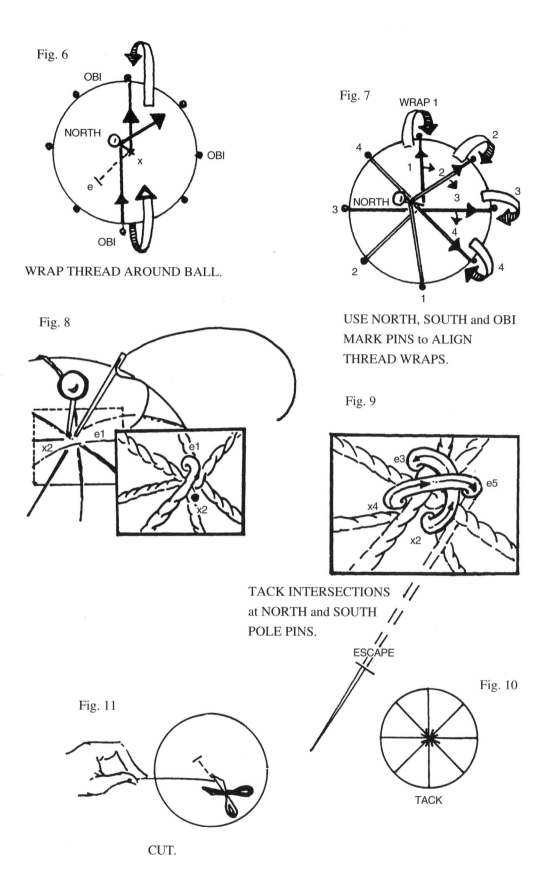

Fig. 6

OBI

NORTH

OBI

OBI

WRAP THREAD AROUND BALL.

Fig. 7

WRAP 1

4

1

2

2

NORTH

3

3

3

4

2

1

USE NORTH, SOUTH and OBI
MARK PINS to ALIGN
THREAD WRAPS.

Fig. 8

x2

e1

e1

x2

Fig. 9

e3

e5

x4

x2

TACK INTERSECTIONS
at NORTH and SOUTH
POLE PINS.

ESCAPE

Fig. 10

TACK

Fig. 11

CUT.

MARKING THE OBI LINE

Fig. 12

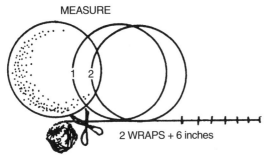

MEASURE

1 2

2 WRAPS + 6 inches

Fig. 13

OBI

NORTH

SOUTH

x2

e1

OBI

Fig. 14

ENTER and WRAP

OBI

NORTH POLE

SOUTH POLE

x2
e3

e1

e5

x4

e3

x6

USE OBI LINE PINS
to ALIGN THREAD WRAP.

Fig. 15

THEN TACK.

THE WAVE — A Wrapped Design

"The Wave" is a very old and traditional wrapped design found on ancient temari. The fine weight thread approximates unraveled silk from discarded clothing. Finer weight thread allows more color to be applied and keeps thread clusters small. A needle is used only to secure the beginning and end of each thread color. DMC Flower Threads are just slightly heavier than one strand of 6-strand embroidery floss.

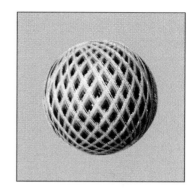

MATERIALS:

3-inch ball wrapped in Aqua Blue

DMC Flower Threads in 6 colors:

 Dark Green #2499

 Deep Teal Blue #2595

 Emerald Green #2956

 Light Green #2952

 Light Aqua #2599

 Lavender #2209

Kreinik Balger — 1 spool each:

 Silver Blending Filament #001

 Silver Medium Braid #16-001

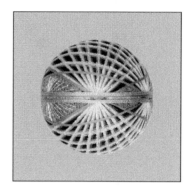

DIVIDE the ball into 6ths around the Obi Line. MARK the ball with the SILVER Blending Filament #001.

Fig. 1

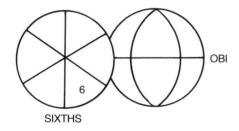

SIXTHS

TACK the NORTH and SOUTH POLES and the 6 DIVISIONS around the OBI LINE.

Fig. 2

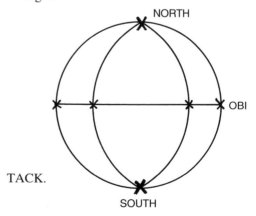

TACK.

TO MARK THE PATTERN:

CUT 4 PAPER TABS.
Mark them A, B, C, D.

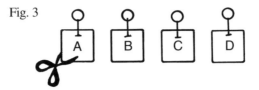

Fig. 3

TO SET THE TABS AS MARKERS around the Obi Line, follow Figures 4 and 5.
PLACE KEEPER PINS at A, B, C, D on the Obi Line.

Fig. 4

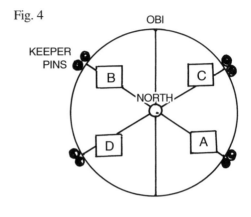

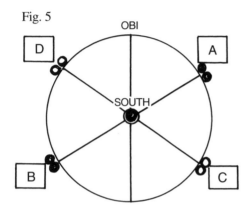

Fig. 5

Use your CENTIMETER TAPE.
Measure from the NORTH POLE PIN toward the OBI.

Fig. 6

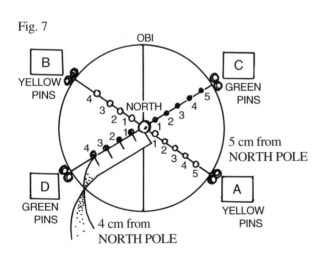

Fig. 7

5 cm from NORTH POLE

4 cm from NORTH POLE

Use YELLOW PINS for A, B line.
Use GREEN PINS for C, D line.
Place pins 1 centimeter apart along the mark lines, 4 pins on one side, 5 pins on the other, NORTH and SOUTH.
(The design will balance as it is completed).
Follow Figure 7 to mark North and Figure 8 for South.

Fig. 8

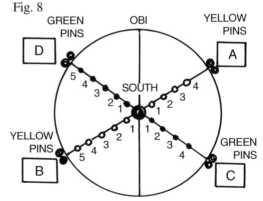

Every row BEGINS and ENDS through the Keeper Pins at "A" or "D."

30

Fig. 9

PREVIEW: First read instructions through Figure 12. Begin at Figure 13.

THREAD NEEDLE.
DO NOT CUT THREAD FROM BALL.

ENTER AND EXIT.
REMOVE NEEDLE FROM THREAD, PULL THREAD'S END UNDER BALL'S SURFACE.

ENTER the needle at "A" Keeper Pins so it EXITS AWAY.

Pull thread through.
Remove the needle.
Knot the thread's end.
Pull the knot into the ball.
The thread is ATTACHED to the ball coming out of "A" Keeper Pins.

Fig. 10

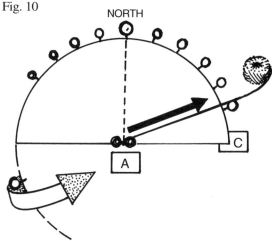

Fig. 11

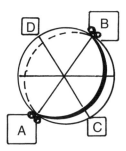

Then wrap across to the Obi Line at B, then on to the South Pole side, inside the pin closest to "D". Then back to "A" at the Obi.

You will be wrapping the thread around the ball TO THE LEFT OF THE PIN EACH TIME.

START toward the RIGHT SIDE pin that is LOWEST and closest to "C" Keeper Pins.

Fig. 12

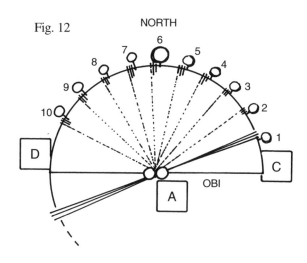

At the KEEPER PINS, each time the thread passes through it changes to the side nearest the pole, North or South.
Wrap each row INSIDE the last. Wrap 3 ROWS at EACH PIN then go on to the next pin.
Wrap across the surface of the ball from RIGHT to LEFT.
See numbers 1 to 10 in Figure 12.

Fig. 13

NORTH

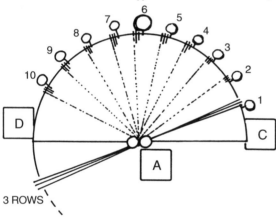

A

X

E

NORTH

A

DARK GREEN
#2499

TO BEGIN, thread your needle with the DARK GREEN #2499.

Hold the ball with the NORTH POLE at the TOP. ENTER your needle at "A" Keeper Pins so it EXITS AWAY.

Fig. 14

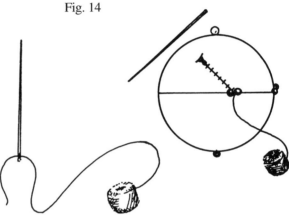

Fig. 15

N

6
7 5
8 4
9 3
10 2
 1

D C

A

3 ROWS

Pull thread through. Remove the needle.
Knot the thread's end.
Pull the knot into the ball.
The thread is ATTACHED to the ball.

Wrap 3 ROWS of DARK GREEN #2499 at each pin.

END and ESCAPE at "A" by cutting thread with 6 inches extra. Thread the end into your needle.

ENTER your needle at the "A" KEEPER PINS so it EXITS AWAY. Pull thread through and CUT at ball's surface.

Fig. 16

N

X

E

A

Fig. 17

At "D," do 3 ROWS of DARK GREEN #2499 INSIDE each pin. Move from Pin 1 on the RIGHT to Pin 10 on the LEFT, across the surface of the ball from "A" toward "B." Use KEEPER PINS "C" and "D."

END and ESCAPE the LAST ROW at "D."

Fig. 18

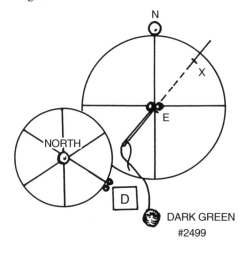

DARK GREEN
#2499

Fig. 19

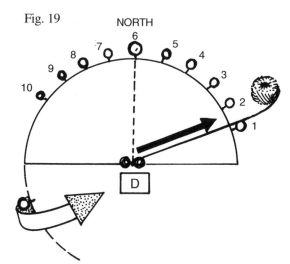

Fig. 20

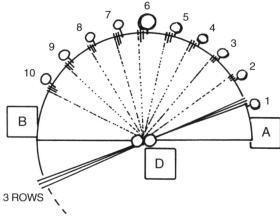

3 ROWS

Fig. 21

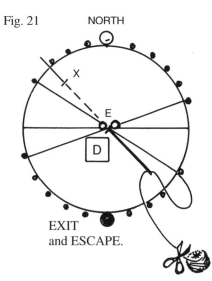

EXIT
and ESCAPE.

Fig. 22

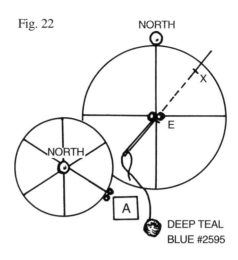

NORTH

X

E

NORTH

A

DEEP TEAL
BLUE #2595

Turn back to "A."
With DEEP TEAL BLUE #2595, wrap 3 ROWS
INSIDE (toward the North Pole).

Fig. 23

2 SILVER FILAMENT #001
2 LIGHT AQUA #2599
2 LIGHT GREEN #2952
3 EMERALD GREEN #2956
3 DEEP TEAL BLUE #2595
3 DARK GREEN #2499

FOLLOW THE PATTERN:

D — 3 Rows DEEP TEAL BLUE #2595
A — 3 Rows EMERALD GREEN #2956
D — 3 Rows EMERALD GREEN #2956
A — 2 Rows LIGHT GREEN #2952
D — 2 Rows LIGHT GREEN #2952
A — 2 Rows LIGHT AQUA #2599
D — 2 Rows LIGHT AQUA #2599
A — 2 Rows SILVER FILAMENT #001
D — 2 Rows SILVER FILAMENT #001.

Fig. 24

4 LAVENDER
#2209

4 LAVENDER
#2209

D A

Use LAVENDER #2209.
Wrap 4 ROWS around only the OUTSIDE of the
pattern, as a border of color.
Wrap 4 ROWS from "A" RIGHT and LEFT.
Wrap 4 ROWS from "D" RIGHT and LEFT.

Fig. 25

The two large DIAMOND SPACES at the Obi Line are filled with the PINE NEEDLE Stitch radiating from the center.

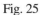

OBI

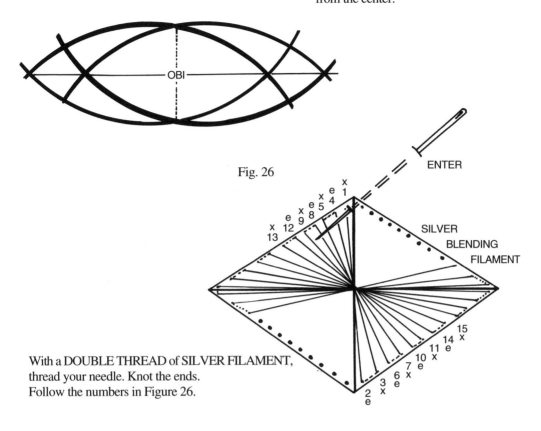

Fig. 26

ENTER

SILVER
BLENDING
FILAMENT

With a DOUBLE THREAD of SILVER FILAMENT, thread your needle. Knot the ends.
Follow the numbers in Figure 26.

Fig. 27

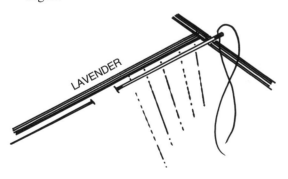

LAVENDER

Take stitches just inside the Lavender line.
Fill in the space with 15 to 20 stitches radiating from the center intersection.

Fig. 28

TACK

TACK the CENTERS lightly with 1 or 2 stitches around the centers.

Fig. 29

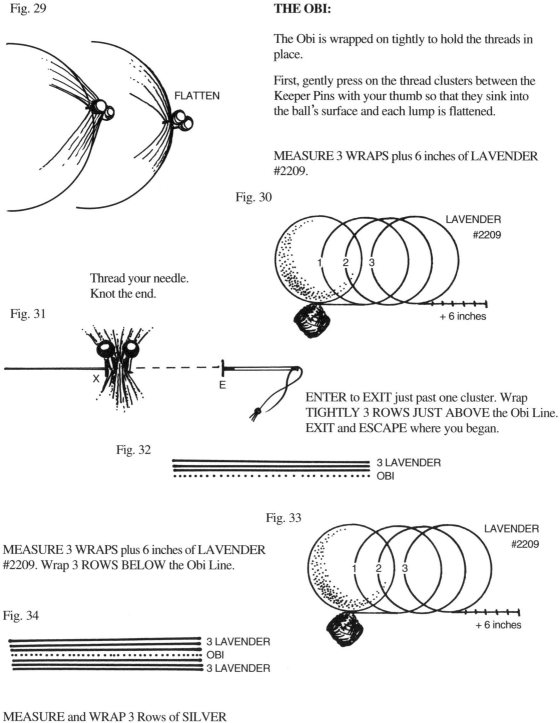

FLATTEN

THE OBI:

The Obi is wrapped on tightly to hold the threads in place.

First, gently press on the thread clusters between the Keeper Pins with your thumb so that they sink into the ball's surface and each lump is flattened.

MEASURE 3 WRAPS plus 6 inches of LAVENDER #2209.

Fig. 30

LAVENDER #2209

1 2 3

+ 6 inches

Thread your needle.
Knot the end.

Fig. 31

X E

ENTER to EXIT just past one cluster. Wrap TIGHTLY 3 ROWS JUST ABOVE the Obi Line. EXIT and ESCAPE where you began.

Fig. 32

3 LAVENDER
OBI

Fig. 33

LAVENDER #2209

1 2 3

+ 6 inches

MEASURE 3 WRAPS plus 6 inches of LAVENDER #2209. Wrap 3 ROWS BELOW the Obi Line.

Fig. 34

3 LAVENDER
OBI
3 LAVENDER

MEASURE and WRAP 3 Rows of SILVER Medium Braid #16-001 ABOVE the LAVENDER.

MEASURE and WRAP 3 Rows of SILVER Medium Braid #16-001 BELOW the LAVENDER.

The ball is complete.

Fig. 35

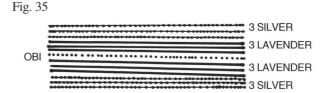

OBI

3 SILVER
3 LAVENDER
3 LAVENDER
3 SILVER

IRIS (AYAME)

Silk ribbon embroidery is explored Japanese-style in this design. The method brings to mind the brush painting techniques of Japanese Sumi-e. With one stroke of the brush, a leaf is created, or the petal of a flower with the twist of a wrist. The silk ribbon performs in a similar way to the Sumi ink.

This design was created with the unforgettable Iris Screen in mind entitled "The Eight-Plank Bridge" from the Edo Period (1603-1867), now in the Metropolitan Museum of Art in New York.

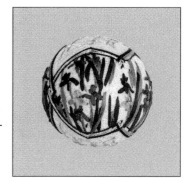

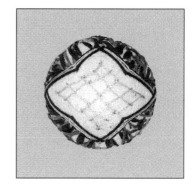

MATERIALS:

3-inch ball — Yellow thread wrap

1 extra small spool of same Yellow thread wrap

Y.L.I. Silk Ribbon in 5 colors:

 2 Purples (4 mm width) —

 Medium Purple #102

 Deep Purple #085

 1 Deep Blue (4 mm width) #099

 2 Greens — Bright Green #19 (4 mm width)

 Leaf Green #021 (7 mm width)

DMC Pearl Cotton #5 — Deep Purple #550

Kreinik's Balger Medium Braid #16 GOLD #002J

Needles — Yarn Darners #18 (your regular needles)

Fig. 1

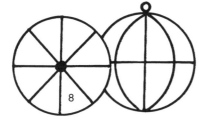

DIVIDE the ball into 8ths around the Obi.

Fig. 2

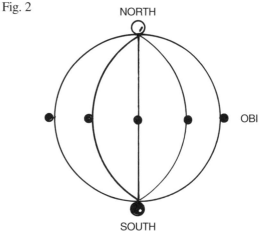

Fig. 3

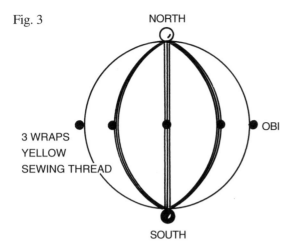

NORTH

3 WRAPS
YELLOW
SEWING THREAD

OBI

SOUTH

With the extra spool of Yellow thread,
MARK the 8ths from NORTH to SOUTH with the
YELLOW WRAP THREAD.

Use 3 wraps of Yellow sewing thread to mark
EACH DIVISION LINE.

Fig. 4

ENTER at the NORTH POLE to EXIT AWAY.
Pull the thread through with the needle.
REMOVE the NEEDLE.

Wrap on the 8 Mark Lines, 3 times each line.

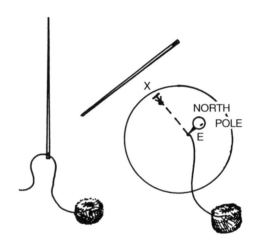

X

NORTH
POLE
E

YELLOW THREAD WRAP

Fig. 5

NORTH

TACK

SOUTH

DO NOT MARK the OBI LINE with thread.
Leave Obi division pins in place.

TACK the NORTH and SOUTH POLES with
Yellow sewing thread.

The 8 Mark Lines will disappear as the silk ribbon is
applied.

THE FRAMES:

DIVIDE 1 LINE into 3rds from the Pole to the Obi Line, North to South.

MARK with pins 1/3 ABOVE and 1/3 BELOW the Obi Line on both sides.

Fig. 6

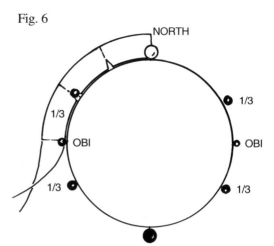

Fig. 7

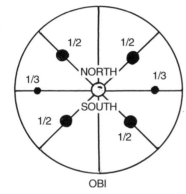

1/2=1/8 of your PAPER MEASURE

DIVIDE the LINES ON EITHER SIDE in 1/2 from the Pole to the Obi, North and South.

Fig. 8

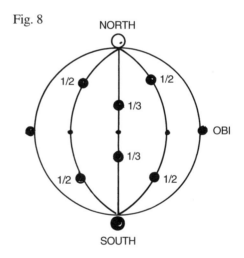

MARK the 1/2s with pins North and South.

Fig. 9

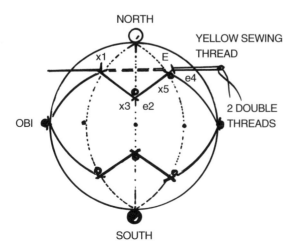

Stitch the frames' outlines with the Yellow sewing thread.
These are guidelines, they will disappear also.

Use 2 DOUBLE THREADS so the outline is visible.

Stitch the shape in Figure 10 on one side, then on the other side.

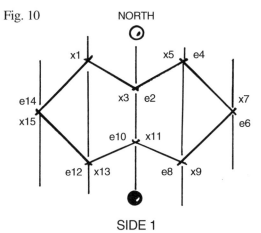

Fig. 10

NORTH

x1 x5 e4
e14 x3 e2 x7
x15 e6
 e10 x11
e12 x13 e8 x9

SIDE 1

This sketched-in guideline will aid in the placement of the embroidery pattern.

Fig. 11

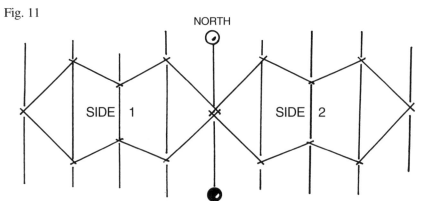

NORTH

SIDE 1 SIDE 2

THE SILK EMBROIDERY

With this method, the ribbon should not be pulled tight. The width of the ribbon as it is laid, flat or twisted, produces the unique turns of the leaves and petals. Give the ribbon some freedom to do what it does. The convex surface of the ball will hold the ribbon in place.

SOME GENERAL INSTRUCTIONS:

Cut lengths of ribbon no longer than about 12 inches. If the length is too long, it is difficult to control and it creates more wasted left-overs.

To THREAD YOUR NEEDLE, run the ribbon through the eye. Pull through 3 to 4 inches. Then pierce the ribbon with the needle 1/8 inch from the end. Pull the pierced end of ribbon down toward the eye. Pull the loop of ribbon back through the eye to tighten. Your needle is locked onto the ribbon.

TO THREAD YOUR NEEDLE

Fig. 12

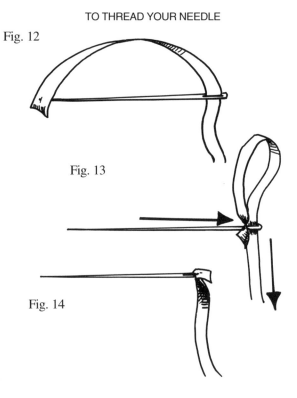

Fig. 13

Fig. 14

40

Fig. 15

THREAD
7 mm
RIBBON

To thread the 7 mm wide ribbon, cut the end at an angle. Thread the point through, then pierce the end.

Start a couple of practice flowers WITHOUT the needle locked-on to the ribbon. The ribbon can still be removed easily from the ball and used again for the next try.

The ribbon will slide through the wrap threads with ease unless another ribbon gets in the way. If you run into another ribbon beneath the surface, back out and dig deeper to go under it.

ENTER and EXIT either STRAIGHT UP or STRAIGHT DOWN (toward the Poles) OUTSIDE THE FRAMES. (Figure 16).

This will help to avoid running into other ribbons under the surface threads.

Fig. 16

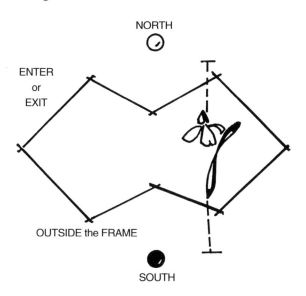

NORTH

ENTER
or
EXIT

OUTSIDE the FRAME

SOUTH

ESCAPE the ribbon as you would with DMC #5. BE CAREFUL NOT TO PULL THE LAST STITCH TOO TIGHT. Exit the needle. Pull the ribbon taut to CUT at the ball's SURFACE. Hold the last stitch in place so it does not lose shape. If necessary, push the end back under the surface with the eye-end of the needle.

As with the Pearl Cotton #5, ENTER under the surface at least 1 inch away from your EXIT and the ribbon will stay in place. NO KNOT IS NEEDED.

Use ANOTHER NEEDLE, unthreaded, as your LAYING TOOL to help place and control the twists and turns and to help flatten the ribbon.

Place a TWIST in the ribbon by spinning the needle. LAY the stitch in place. HOLD the stitch in place with the THUMB of the LEFT HAND. Then gently pull the thread through.

THE STEMS

Within the frames, the stems will be stitched first, the flowers will be stitched over them. Stems should come out of the center bottom of the flower, not float off from the bottom petal.

The trick to more natural looking stems is knowing that they are never really straight. There are always some crooks and turns and angles. Leaves don't grow off the sides of the stem every time. They grow from the front, the back, and sometimes wrap around.

Fig. 17

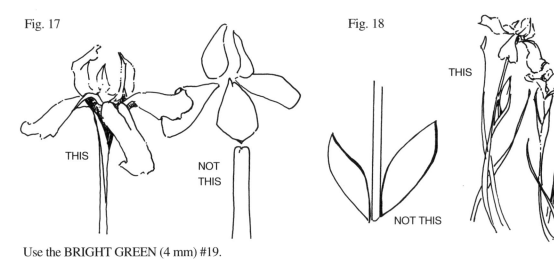

THIS

NOT THIS

Fig. 18

THIS

NOT THIS

Use the BRIGHT GREEN (4 mm) #19.

To stitch the stems is easy. Each stem is one long stitch with the ribbon twisted several times. Use the pattern to guide your placement. WORK FROM RIGHT TO LEFT WITHIN THE FRAMES.

Fig. 19

SIDE 1

THE STEMS

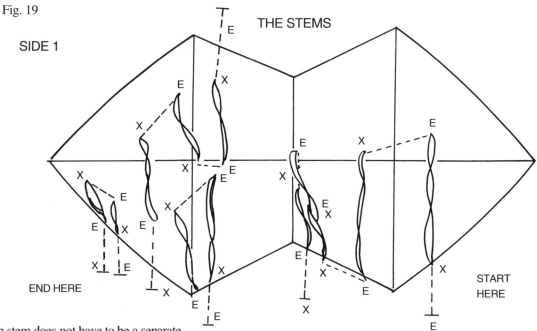

END HERE

START HERE

Each stem does not have to be a separate Enter, Exit, Escape. To move from one to the next, simply RUN the ribbon UNDER the ball's SURFACE to the next EXIT.

42

Fig. 20

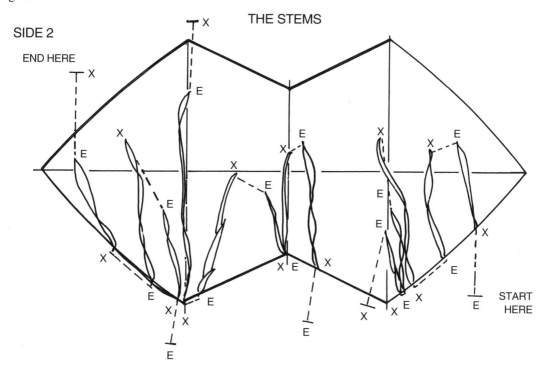

SIDE 2

END HERE

START HERE

THE FLOWERS

The basic shape of the flower is shown in Figure 21.
However, like people, each is an individual.

Fig. 21

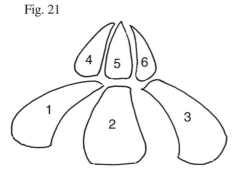

Fig. 22

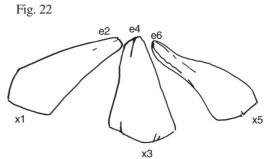

The twist of the ribbon gives the turn of a petal or a
different angle to the flower. Let the ribbon help to
give the blossoms their individual personalities.

Fig. 23

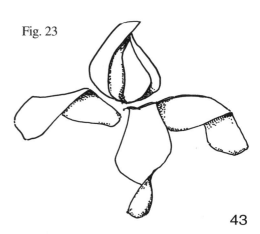

43

Leave SPACE AROUND THE OUTSIDE of the flowers. The SILHOUETTE is what makes them identifiable. Don't bunch them together.

Don't pull too tight or the ribbon will lose its flair.

For the crowns, some stitches pulled tight give smaller sized petals. The longer petals are left loose.

Fig. 24

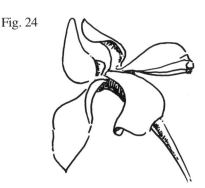

Fig. 25

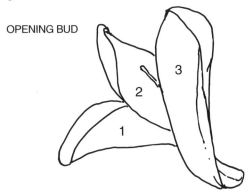

OPENING BUD

The opening buds are 3 petals facing upward.

Fig. 26

CLOSED BUD

TWISTED

The closed buds are 1 stitch left loose.

Place the FLOWERS in the frames OVER the STEMS.
WORK FROM RIGHT TO LEFT within the frames.

Fig. 27

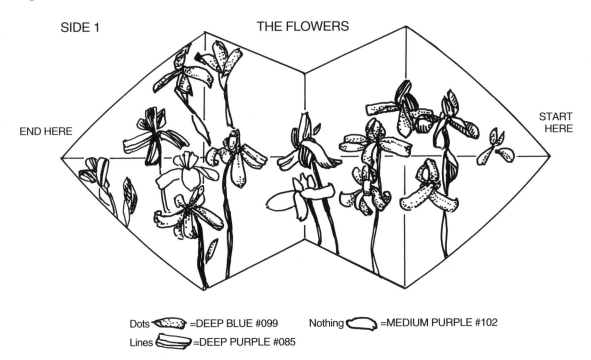

SIDE 1 THE FLOWERS

END HERE

START HERE

Dots =DEEP BLUE #099 Nothing =MEDIUM PURPLE #102
Lines =DEEP PURPLE #085

Fig. 28

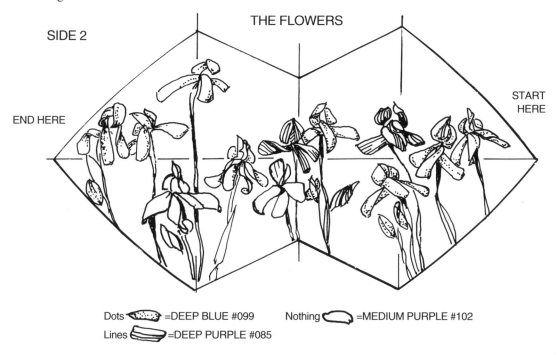

SIDE 2

THE FLOWERS

END HERE

START HERE

Dots ⬭ =DEEP BLUE #099 Nothing ⬭ =MEDIUM PURPLE #102
Lines ⬭ =DEEP PURPLE #085

THE LEAVES

Like the stems, the leaves are one long stitch, twisted or laid flat. Leaves go in front or behind the stems and flowers. The ribbon can easily be pushed behind a stem or a flower petal with the eye-end of the needle.

Use the WIDE (7 mm) LEAF GREEN #021 and the (4 mm) BRIGHT GREEN #19.

Again, the stitches can be connected under the ball's surface. If another ribbon gets in the way, DIG DEEPER and go way BELOW it.

Fig. 29

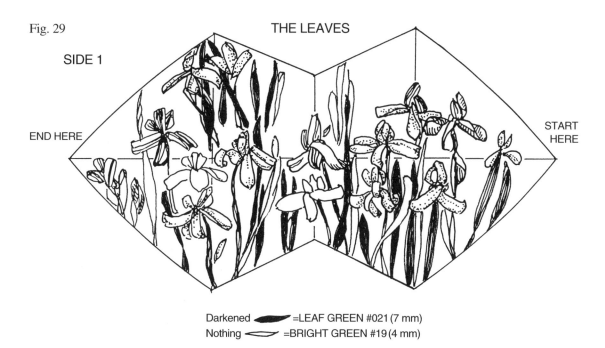

THE LEAVES

SIDE 1

END HERE

START HERE

Darkened ⬭ =LEAF GREEN #021 (7 mm)
Nothing ⬭ =BRIGHT GREEN #19 (4 mm)

45

Fig. 30 THE LEAVES

SIDE 2

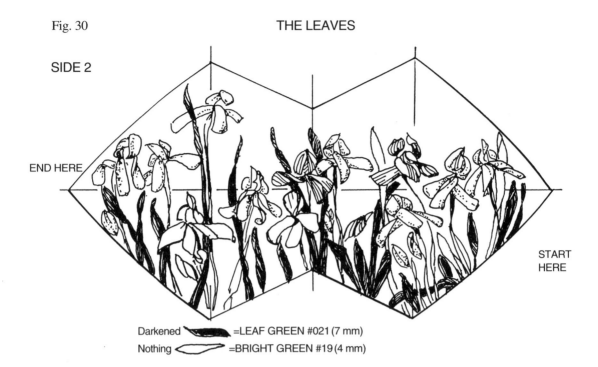

Darkened ▬▬◣ =LEAF GREEN #021 (7 mm)
Nothing ◁▭▬ =BRIGHT GREEN #19 (4 mm)

THE DECORATIVE FRAMES

Use the DMC Pearl Cotton #5 PURPLE #550 and
Kreinik's Balger GOLD MEDIUM BRAID #16.

The PATTERN:
 1 Row DMC PURPLE #550
 2 Rows GOLD MEDIUM BRAID #16
 2 Rows PURPLE #550.

Fig. 31

Fig. 32

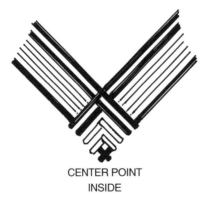

In the CENTER POINTS, the "Chrysanthemum"
or "Kiku" Stitch creates the pattern.

Fig. 33

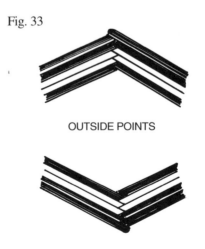

The OUTSIDE POINTS create boundaries (turn the
ball as you stitch 1 row OUTSIDE the last).

Fig. 34

The SIDE CORNERS

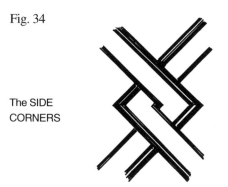

The SIDE CORNERS INTERLOCK. Push the thread under the others with the EYE-END of the needle.
REPEAT ON THE OPPOSITE SIDE.

Fig. 35

NORTH and SOUTH

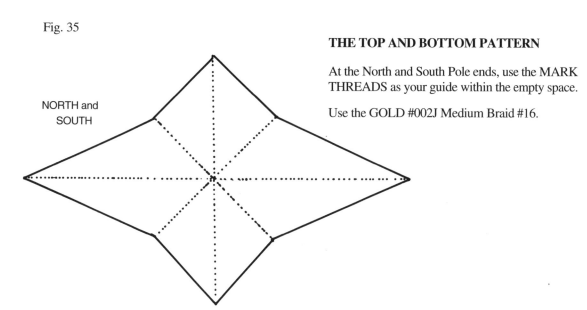

THE TOP AND BOTTOM PATTERN

At the North and South Pole ends, use the MARK THREADS as your guide within the empty space.

Use the GOLD #002J Medium Braid #16.

ROW 1: Stitch the same shape 1/2 inch inside the frame.
Use the boundary as your guide.

ENTER to EXIT at a POINT. Turn the ball as you stitch. Take the stitch at the bottom of the pattern each time.

Fig. 36

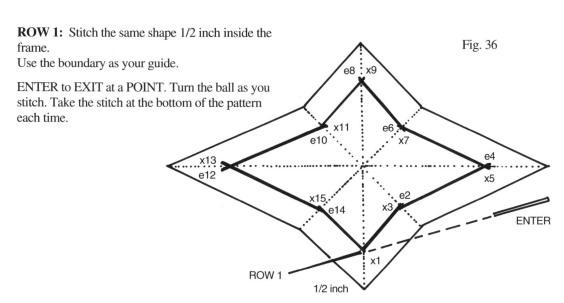

47

ROW 2: ENTER to EXIT 1/2 way up the line.
Complete Row 2 going UNDER the POINTS.

Fig. 37

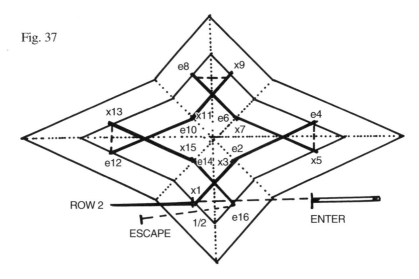

ROW 3: ENTER to EXIT at the CORNER.
Stitch a large CROSS STITCH over the CENTER.

Fig. 38

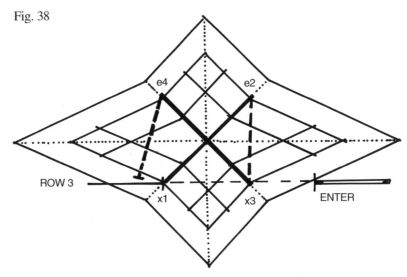

TACK the CENTER.

REPEAT the pattern at the opposite Pole.

The ball is complete.

WISTERIA (FUJI)

One of the favorite flower motifs of Japan is the Wisteria vine. The fragrant and lavish cascading blooms epitomize the glory of Spring. Again silk ribbon is used for this design. The same frame motif as in Ball 2A is repeated in order to coordinate the two balls' designs.

MATERIALS:

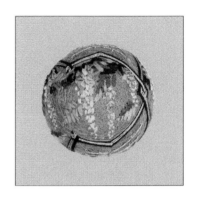

3-inch ball — Turquoise Blue thread wrap
1 small spool of extra thread wrap color to use for
 marking thread
Y.L.I. SILK RIBBON in 8 colors ALL 4 mm
 WIDTH:
 3 Greens — Spring #95
 Kelly #96
 Forest #61
 4 Purples — Deep #85
 Medium #102
 Lavender #101
 Light #100
 1 White #1
DMC Pearl Cotton #5 — Deep Purple #550
Kreinik's Balger Medium Braid #16 GOLD #002J
Needle — Yarn Darner #18

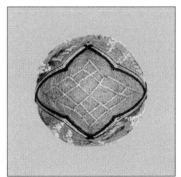

DIVIDE the ball into 8ths around the Obi.

MARK the 8ths North and South with the Turquoise extra thread wrap.

Follow the Dividing and Marking instructions in the Iris Ball, page 37.

THE FRAMES

Refer back to Iris Ball, page 39. The frames for "Wisteria" are identical.

Stitch the frames' outlines with 2 DOUBLE THREADS of TURQUOISE wrap thread.

THE FLOWERS

Wisteria has long cone-shaped blooms that are commonly 14 to 20 inches in length. The tiny fragile flowers on each bloom graduate in size, large to small, and in color, dark to light, from top to bottom.

Fig. 39

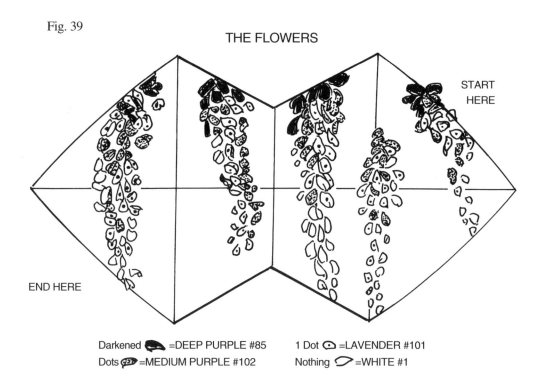

THE FLOWERS

START HERE

END HERE

Darkened [symbol] =DEEP PURPLE #85
Dots [symbol] =MEDIUM PURPLE #102

1 Dot [symbol] =LAVENDER #101
Nothing [symbol] =WHITE #1

Start at the TOP with the DARKEST PURPLE #085.

The blooms are shaded with the medium shades around the sides of the top half. The bottom half is LIGHT LAVENDER #100 and WHITE #1.

The STITCHES are simply random, loose, satin stitches. The texture is more important than the actual stitches.

Leave some BACKGROUND COLOR SHOWING THROUGH. This gives the lacy effect.

Use the pattern within the OUTLINE FRAME to help place the blossoms.
START AT THE RIGHT AND WORK TO THE LEFT within the frame.

THE LEAVES

The leaves of the Wisteria vine are 10 to 12 spear-shapes alternating along a stem of 8 to 10 inches. They are feathery and the color of new Spring growth. As the season progresses and the flowers mature, the greens become deeper and the foliage dense.

Fig. 40

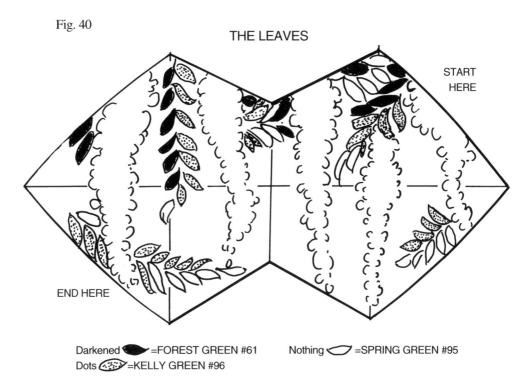

THE LEAVES

START HERE

END HERE

Darkened ⬛=FOREST GREEN #61
Dots 🔘=KELLY GREEN #96

Nothing ⬜=SPRING GREEN #95

To stitch the leaves, start with the FOREST GREEN #61. Dark colors appear to recede and light colors come forward. The darks provide the background and the shadows and so they are laid down first. The medium shades are next. The lightest colors appear the closest, so they should be applied last.

Use the pattern to place the leaves.

START ON THE RIGHT AND WORK TOWARD THE LEFT within the frame.

REPEAT the pattern on the opposite side of the ball.

THE DECORATIVE FRAMES

As with the Iris Ball, the frames use the DMC #5 — DEEP PURPLE #550 and Kreinik's GOLD #002J Balger MEDIUM BRAID #16.

Again, the pattern is:
 1 Row DEEP PURPLE DMC #550
 2 Rows GOLD Medium Braid #16
 2 Rows DEEP PURPLE DMC #550.

Refer back to page 46 for details.

REPEAT the frame on the opposite side of the ball.

THE TOP AND BOTTOM PATTERN

For the North and South Pole pattern, refer back to "Iris" for instructions.

The ball is complete.

SPIDER WEB DEWDROPS

This design brings to mind early morning beads of dew on an intricate spider web. The "Spider Web" stitch is used with the threads submerged beneath the ball's surface.

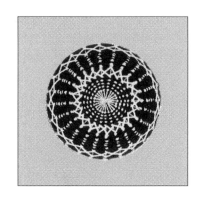

MATERIALS:

3-inch ball - Black thread wrap
DMC Pearl Cotton #5 in 3 colors:
> Black #310
> White #005
> Red Orange #606

Marking Thread — Kreinik's Balger Ombre GOLD #2000
Paper circle 1.5 cm diameter
2 Needles

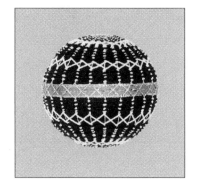

DIVIDE the ball into 24ths around the Obi. (Divide into 1/8s, then divide each 1/8 into 1/3s). Your centimeter tape is helpful.

Fig. 1

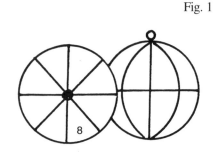

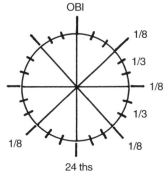

Fig. 2

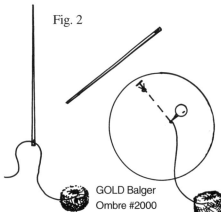

MARK the ball with the GOLD Balger Ombre #2000.

Fig. 3

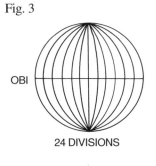

TACK the North and South Poles.
MARK the OBI.
TACK the 24 intersections.

Fig. 4

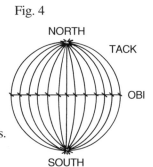

Fig. 5

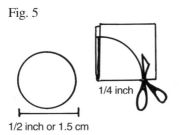

1/4 inch

1/2 inch or 1.5 cm

CUT a PAPER CIRCLE 1.5 cm in diameter. This will be a guideline for the center around the poles. Any paper will do.

Fold the paper in 1/2 then into 1/4s to cut.

Fig. 6

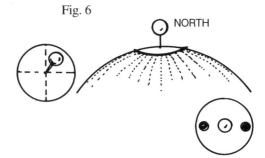

NORTH

Use the center intersection of fold lines to pin to the exact center of the NORTH POLE.

SECURE the circle in place with 2 more pins.

Fig. 7

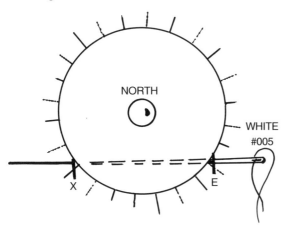

NORTH

WHITE
#005

X

E

THE SPIDER WEB STITCH

Needle #1:

Thread needle with WHITE #005 DMC Pearl Cotton #5.

ENTER the needle so that it EXITS just OUTSIDE the paper circle and just to the LEFT of one of the marking threads.

Pull the thread through until the end disappears under the ball's surface.

With the WHITE #005, take a backstitch that loops around each GOLD marking thread, UNDER 2 THREADS and OVER 1 thread.

The needle goes under the ball's surface in between so the WHITE thread is submerged and not seen. Only the loop shows above the surface.

Continue CLOCKWISE around the circle, ONE stitch of WHITE over each GOLD marking thread, right next to the paper. End where you began. Stick the WHITE needle into the ball out of your way.

Fig. 8

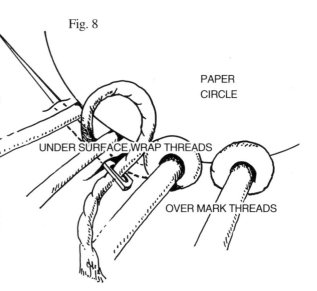

PAPER CIRCLE

UNDER SURFACE WRAP THREADS

OVER MARK THREADS

Thread Needle #2 with BLACK #310.

ENTER to EXIT just OUTSIDE the WHITE row.

Do 1 BLACK ROW around the WHITE Row, right up next to it.

Use a START PIN to mark your BEGINNING and END.

Fig. 9

BLACK #310

E

NORTH

START

THREAD 2 NEEDLES
WITH 2 COLORS
TO ALTERNATE
QUICKLY.

Continue around the circle with:

 1 Row WHITE #005
 1 Row BLACK #310
 1 Row WHITE #005
 1 Row BLACK #310
 1 Row WHITE #005
 1 Row BLACK #310.

A TOTAL of 8 ROWS around the North Pole alternating Black and White.

Fig. 10

EACH ROW
GOES AROUND

START

Fig. 11

ZIG ZAG

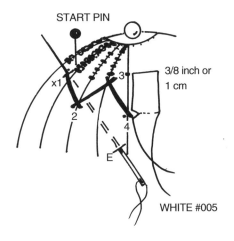

START PIN

3/8 inch or
1 cm

x1

2

3

4

E

WHITE #005

ZIG ZAG

MEASURE 1 cm or 3/8 inch down from the last row toward the Obi.

With WHITE #005, do a ZIG ZAG ROW around the ball.

Fig. 12

START PIN

ZIG ZAG 1

ZIG ZAG 2

X

X

E

E

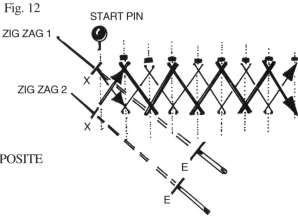

Do a SECOND ZIG ZAG ROW on OPPOSITE mark lines to make DIAMONDS.

Fig. 13

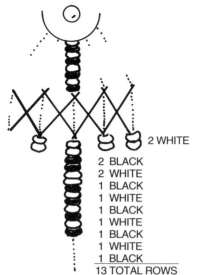

NORTH

2 WHITE

2 BLACK
2 WHITE
1 BLACK
1 WHITE
1 BLACK
1 WHITE
1 BLACK
1 WHITE
1 BLACK
13 TOTAL ROWS

Beneath the Zig Zag, continue the pattern:

2 Rows WHITE #005
2 Rows BLACK #310
2 Rows WHITE #005
1 Row BLACK #310
1 Row WHITE #005
1 Row BLACK #310
1 Row WHITE #005
1 Row BLACK #310
1 Row WHITE #005
1 Row BLACK #310.

Fig. 14

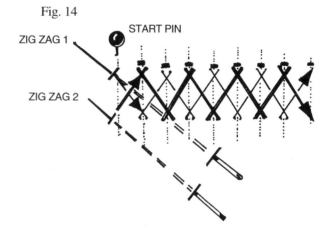

START PIN

ZIG ZAG 1

ZIG ZAG 2

Fig. 15

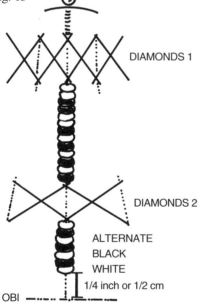

DIAMONDS 1

DIAMONDS 2

ALTERNATE
BLACK
WHITE
1/4 inch or 1/2 cm

OBI

REPEAT THE DOUBLE ZIG ZAG:

MEASURE down 1 cm or 1/2 inch.
With WHITE #005, do 1 zig zag around then use
the opposite zig zag to create Diamonds.
They will be wider this time.

Continue the pattern by alternating WHITE and
BLACK ROWS, 1 White, 1 Black, to 1/4 inch or
1/2 cm above the Obi Mark Line. Fill in with as
many rows as necessary (6 to 8).

REPEAT the identical pattern at the SOUTH
POLE.

Fig. 16

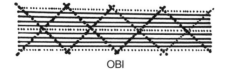

OBI

THE OBI:

The Obi is wrapped on. Over it is a stitched zig zag
using the mark lines.

Fig. 17

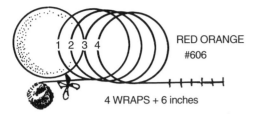

RED ORANGE
#606

4 WRAPS + 6 inches

MEASURE and CUT 4 WRAPS plus 6 inches of
RED ORANGE #606.

Thread your needle.

Fig. 18

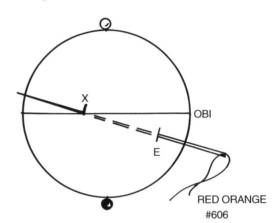

X

OBI

E

RED ORANGE
#606

ENTER to EXIT just ABOVE the Obi Mark Line.

Fig. 19

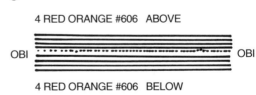

4 RED ORANGE #606 ABOVE E

END

OBI

BEGIN

X

WRAP 4 ROWS of RED ORANGE ABOVE the
Obi Mark Line.
EXIT and ESCAPE.

Fig. 20

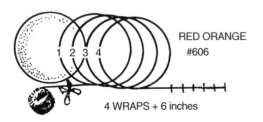

RED ORANGE
#606

4 WRAPS + 6 inches

MEASURE and WRAP 4 ROWS of RED
ORANGE #606 BELOW the Obi Mark Line.

Fig. 21

4 RED ORANGE #606 ABOVE

OBI OBI

4 RED ORANGE #606 BELOW

Fig. 22

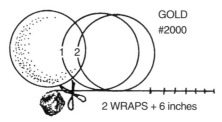

GOLD
#2000

2 WRAPS + 6 inches

MEASURE 2 WRAPS plus 6 inches of GOLD
Balger Ombre #2000.

Fig. 23

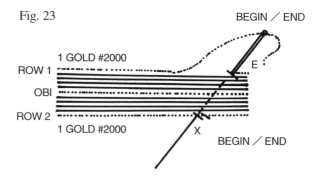

BEGIN / END

1 GOLD #2000
ROW 1
OBI
ROW 2
1 GOLD #2000

E

X

BEGIN / END

ENTER to EXIT ABOVE the 4 RED ORANGE
#606 rows. WRAP once around. END where you
BEGAN. ENTER to EXIT the second wrap
BELOW the 4 ORANGE rows. Wrap once around.
END where you BEGAN.

Fig. 24

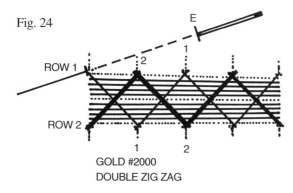

E

ROW 1

ROW 2

GOLD #2000
DOUBLE ZIG ZAG

Thread your needle with the GOLD Balger Ombre
#2000.

Use the 24 MARK LINES AROUND the Obi to
stitch a DOUBLE ZIG ZAG (Diamonds) over the
wrapped Obi.

The ball is complete.

The Double Eighths Mark

The DOUBLE EIGHTHS
MARK SYMBOL

Fig. 1

Divide into 8ths with an OBI LINE.

Fig. 2

TACK all 8 intersections around the Obi,
and the NORTH and SOUTH POLES.

Fig. 3

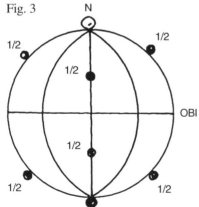

Divide every other line in 1/2 between NORTH
and OBI and SOUTH and OBI.
Mark with pins.

Fig. 4

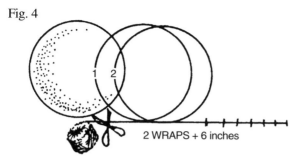

2 WRAPS + 6 inches

MEASURE 2 WRAPS plus 6 inches of marking thread.

Fig. 5

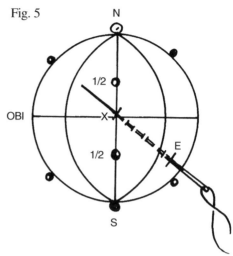

ENTER the needle so that it EXITS at the OBI LINE and an intersection of one 1/2 MARKED LINE.

Fig. 6

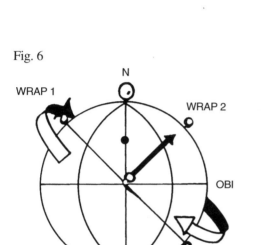

WRAP the thread diagonally (at a 45 degree angle) to the 1/2 mark pin on the LEFT, then continue around the ball.
TURN the direction of the thread at the Start Pin and wrap to the RIGHT.

Fig. 7

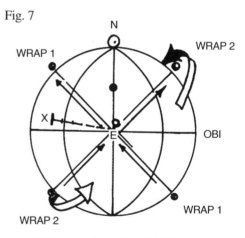

END at the Start Pin. TACK.
EXIT and ESCAPE the needle.

Fig. 8

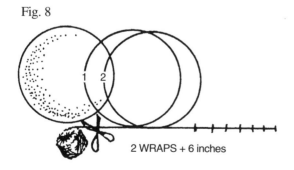

2 WRAPS + 6 inches

MEASURE 2 more WRAPS plus 6 inches of marking thread.

Fig. 9

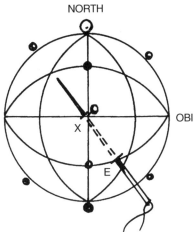

NORTH

OBI

X

E

TURN the ball a QUARTER TURN.
ENTER to EXIT at the OBI and
a 1/2 marked intersection.

Fig. 10

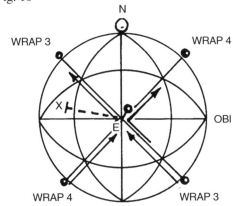

N

WRAP 3

WRAP 4

X

OBI

E

WRAP 4

WRAP 3

WRAP DIAGONALLY to LEFT
and RIGHT.
END and EXIT.

TACK DIAGONAL INTERSECTIONS at OBI.

Fig. 11

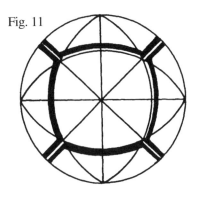

Fig. 12

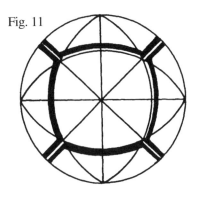

This mark is symmetrical.
It provides 6 EQUAL SQUARES
and 8 EQUAL TRIANGLES,
4 NORTH and 4 SOUTH.

Fig. 13

This is the Double Eighths Mark symbol.

INTRIGUE

This symmetrical pattern interlocks four "chevrons" with one continuous line. The design lends itself to a very formal ball with the traditional Dragonfly Knots and Tassels applied to sides and bottom. Three color combinations are given for Balls A, B, and C.

Ball A — MATERIALS:

3-inch ball — Mustard Yellow thread wrap
 (color of Grey Poupon mixed with mayonnaise)
From the "CARON COLLECTION," threads
 in 4 colors:
 WATERCOLORS "Pussywillow" #092
 (3-ply cotton — use one ply)
 CORNSILK woven rayon ribbon
 Moss Green #V-13
 Persimmon #V-19
 ANTIKA Metallic chainette
 Terra Cotta #AT-7
DMC Pearl Cotton #5 — Dark Olive Green #935
Marking thread — Kreinik's Balger Medium Cord
 GOLD #002J

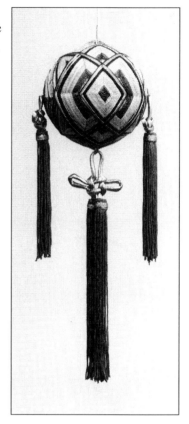

DIVIDE the ball into DOUBLE EIGHTHS.

MARK the ball with the Balger GOLD Medium Cord #002J.

Fig. 1

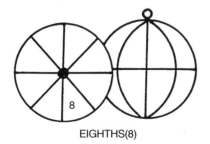

EIGHTHS(8)

DOUBLE EIGHTHS

Fig. 2

TACK

TACK the NORTH and SOUTH POLES, the 4 MAIN OBI INTERSECTIONS, and the TRIANGLE CENTERS.

No further measurements are needed.

Fig. 3

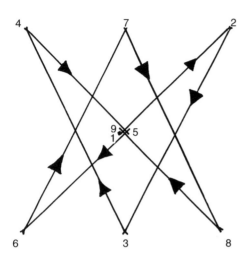

Follow the arrows and numbers in Figure 3.
Trace the direction of the pattern with your finger.

Thread your needle with ANTIKA "Terra Cotta"
#AT-7 metallic chainette.

Fig. 4

ENTER to EXIT at the Obi Line JUST to the LEFT
and BELOW the CENTER INTERSECTION.

Fig. 5

TURN the ball with each stitch COUNTER-
CLOCKWISE. Take the stitch at the TOP of
the pattern each time.

Fig. 6

Fig. 7

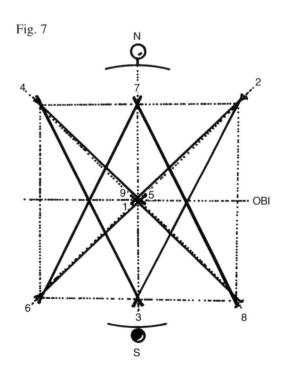

To STITCH the pattern, follow the NUMBERS
in Figures 6 and 7.

Fig. 8

ROW 2 goes OUTSIDE of ROW 1.

Do 3 ROWS of ANTIKA "Terra Cotta" copper
metallic #AT-7.
END where you BEGAN.
EXIT and ESCAPE.

Do 1 ROW of CORNSILK "Persimmon" woven
ribbon #V-19. Start again at #1.
Lay the ribbon FLAT.
MITER the CORNERS.
END where you BEGAN.

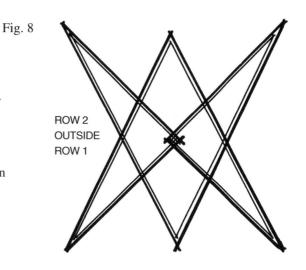

ROW 2
OUTSIDE
ROW 1

Fig. 9

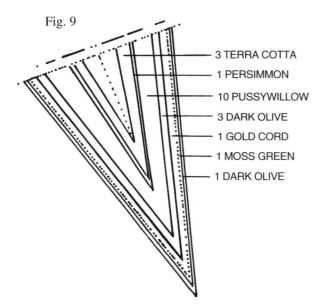

3 TERRA COTTA
1 PERSIMMON
10 PUSSYWILLOW
3 DARK OLIVE
1 GOLD CORD
1 MOSS GREEN
1 DARK OLIVE

With WATERCOLORS "Pussywillow" #092,
use 1 STRAND.

Do 10 ROWS of 1 strand of "Pussywillow" #092
outside the "Persimmon" Cornsilk #V19.

With the DMC Pearl Cotton #5 DARK OLIVE
GREEN #935, do 3 ROWS outside the
"Pussywillow" WATERCOLORS #092.

Do 1 ROW of GOLD Balger Medium Cord #002J.

1 Row of CORNSILK woven ribbon MOSS
GREEN #V-13.

1 Row of DMC Pearl Cotton #5 DARK OLIVE
GREEN #935.

One pattern is complete.

REPEAT the pattern exactly on the OPPOSITE
SIDE of the ball:
 3 Rows ANTIKA "Terra Cotta" copper
 metallic #AT-7
 1 Row CORNSILK "Persimmon" woven
 ribbon #V-19
 10 Rows "Pussywillow" #092 — 1 strand
 3 Rows DMC Pearl Cotton #5 DARK OLIVE
 GREEN #935
 1 Row GOLD Balger Medium Cord #002J
 1 Row CORNSILK "Moss Green" woven
 ribbon #V-13
 1 Row DMC Pearl Cotton #5 DARK OLIVE
 GREEN #935.

Fig. 10

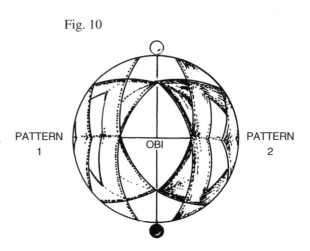

PATTERN
1

OBI

PATTERN
2

IN THE SIDE SQUARES:

Use the vertical / horizontal Mark Lines to stitch a DIAMOND shape.

Fig. 12

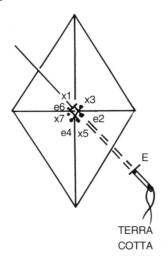

TERRA
COTTA

Fig. 11

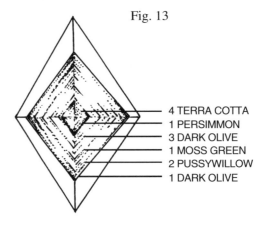

THE SIDE SQUARES

Start in the CENTER. Stitch to within 1/2 inch of the pattern on both sides.

4 Rows ANTIKA "Terra Cotta" copper metallic #AT-7.
1 Row CORNSILK "Persimmon" woven ribbon #V-19.
3 Rows DMC Pearl Cotton #5 DARK OLIVE GREEN #935.
1 Row CORNSILK "Moss Green" woven ribbon #V-13.
2 Rows "Pussywillow" #092 − 1 strand.
1 Row DMC Pearl Cotton #5 DARK OLIVE GREEN #935.

REPEAT the IDENTICAL DIAMOND pattern on the OPPOSITE SIDE.

Fig. 13

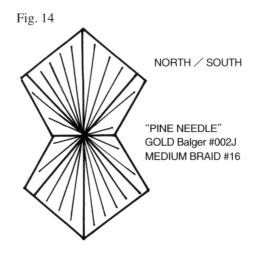

4 TERRA COTTA
1 PERSIMMON
3 DARK OLIVE
1 MOSS GREEN
2 PUSSYWILLOW
1 DARK OLIVE

With GOLD Balger Medium Braid #002J, add PINE NEEDLE STITCHES around the NORTH and SOUTH POLE spaces.

Add tassels with Dragonfly Knot made of Rust ("Persimmon") Bunka thread and Gold cord.

Attach tassels to the center of the Diamond shapes and to the SOUTH POLE.
Refer to "Tassels" Chapter 11.

The ball is complete.

Fig. 14

NORTH / SOUTH

"PINE NEEDLE"
GOLD Balger #002J
MEDIUM BRAID #16

Ball B—MATERIALS:

3-inch ball—Medium Gray thread wrap

"The CARON COLLECTION" threads in 4 colors:

WILDFLOWERS— "Grand Canyon" #009 single strand cotton
CORNSILK "Persimmon" #V19 woven ribbon
ANTIKA "Midnight" #AT-12 Navy Blue metallic chainette
SNOW metallic chainette—Pearl White—no color number

Marking thread—Kreinik's Balger Ombre GOLD #2000

THE MAIN PATTERN:

3 Rows ANTIKA "Midnight" #AT-12 Navy
 Blue chainette
2 Rows SNOW Pearl White chainette
9 Rows WILDFLOWERS "Grand Canyon"
 #009—1 ply cotton
1 Row CORNSILK "Persimmon" #V-19
 woven rayon ribbon
2 Rows ANTIKA "Midnight" #AT-12 Navy
 Blue chainette.

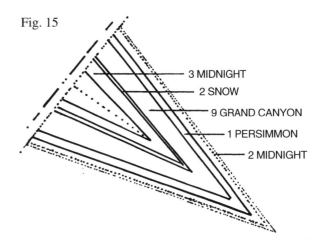

Fig. 15

3 MIDNIGHT
2 SNOW
9 GRAND CANYON
1 PERSIMMON
2 MIDNIGHT

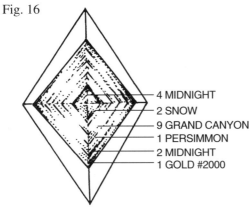

Fig. 16

4 MIDNIGHT
2 SNOW
9 GRAND CANYON
1 PERSIMMON
2 MIDNIGHT
1 GOLD #2000

THE SIDE SQUARES:

4 Rows ANTIKA "Midnight" #AT-12
 chainette
2 Rows SNOW Pearl White chainette
9 Rows "Grand Canyon" #009
1 Row CORNSILK "Persimmon" #V-19
2 Rows ANTIKA "Midnight" #AT-12
 chainette
1 Row GOLD Balger Ombre #2000.

Fig. 17

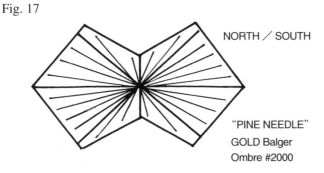

NORTH / SOUTH

"PINE NEEDLE"
GOLD Balger
Ombre #2000

THE PINE NEEDLE STITCHES:

GOLD Balger Ombre #2000.

THE TASSELS:

White Bunka thread with Gold cord.

Ball C—MATERIALS:

3-inch ball—Black thread wrap

Rainbow Gallery's "FIESTA!" 6-ply Rayon Floss in 4 colors:
 Burgundy #F717
 Cherry Red #F716
 Melon #F714
 Steel Gray #F742
Rainbow Gallery's "FYREWERKS" Metallic Ribbon GOLD #F2
Marking thread—Kreinik's Balger Ombre GOLD #2000

Fig. 18

THE MAIN PATTERN:

 1 Row GOLD Fyrewerks #F2
 2 Rows BURGUNDY #F717
 2 Rows CHERRY RED #F716
 2 Rows MELON #F714
 2 Rows STEEL GRAY #F742
 2 Rows BURGUNDY #F717
 1 Row MELON #714
 1 Row GOLD Fyrewerks #F2.

- 1 GOLD FYREWERKS #F2
- 2 BURGUNDY #F717
- 2 CHERRY RED #F716
- 2 MELON #F714
- 2 STEEL GRAY #F742
- 2 BURGUNDY #F717
- 1 MELON #F714
- 1 GOLD FYREWERKS #F2

NOTE: A few TACK STITCHES with your wrapping thread will keep slick rayons in place.

Fig. 19

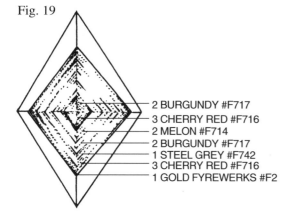

- 2 BURGUNDY #F717
- 3 CHERRY RED #F716
- 2 MELON #F714
- 2 BURGUNDY #F717
- 1 STEEL GREY #F742
- 3 CHERRY RED #F716
- 1 GOLD FYREWERKS #F2

THE SIDE SQUARES:

 2 Rows BURGUNDY #F717
 3 Rows CHERRY RED #F716
 2 Rows MELON #F714
 2 Rows BURGUNDY #F717
 1 Row STEEL GRAY #F742
 3 Rows CHERRY RED #F716
 1 Row GOLD Fyrewerks #F2.

Fig. 20

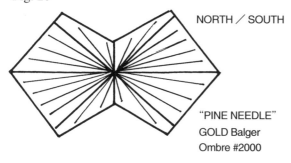

NORTH / SOUTH

"PINE NEEDLE"
GOLD Balger
Ombre #2000

THE PINE NEEDLE STITCHES:

 GOLD Balger Ombre #2000.

THE TASSELS:

 CHERRY RED Bunka thread with Gold cord.

Ball #5

SQUARE DANCE

This pattern combines a stitched square design with a wrapped interweave.

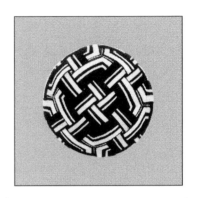

MATERIALS:
3-inch ball — Red thread wrap
DMC Pearl Cotton #5 in 2 colors:
 Red Orange #606 — 2 skeins or 1 ball
 Yellow Orange #741 — 1 skein
Marking thread — Kreinik's Balger Ombre GOLD #2000

For BLACK and WHITE BALL:
3-inch ball — Black thread wrap
DMC Pearl Cotton #5:
 2 skeins Black #310
 (substitute for Red Orange #606)
 1 skein White #005
 (substitute for Yellow Orange #741)
Marking thread — Kreinik's Balger Ombre GOLD #2000

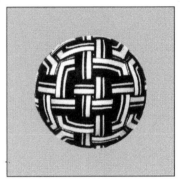

Fig. 1

DIVIDE the ball into DOUBLE EIGHTHS.

Fig. 2

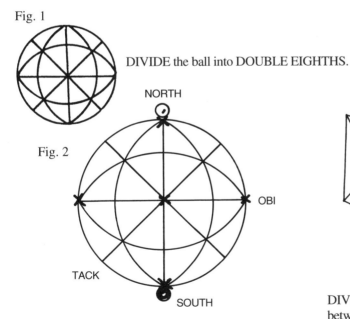

MARK with GOLD Balger Ombre #2000.

TACK the NORTH and SOUTH POLES. TACK the CENTERS of all 4 SQUARES around the Obi.

Fig. 3

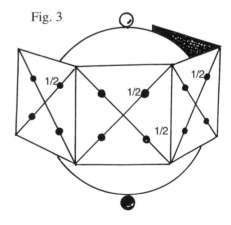

DIVIDE the 4 LONG LINES (Diagonals) in 1/2 between the CENTER and CORNER.
MARK with PINS. This will be the INSIDE BOUNDARY of the Square pattern.

Work first on the 4 Squares AROUND THE OBI.

67

Fig. 4

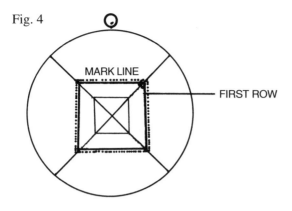

MARK LINE

FIRST ROW

Within each square, the stitched rows go from the OUTSIDE TO THE INSIDE (from LARGE to SMALL).

Fig. 5

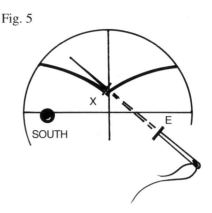

X

SOUTH

E

Hold the ball so that the first square to be stitched is at the TOP of the ball.

Fig. 6

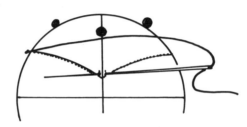

As you stitch, carry the thread ABOVE THE NEEDLE. Stitch as CLOSELY AS POSSIBLE INTO EACH CORNER.
KEEP ROWS CLOSE TOGETHER.
KEEP CORNER STITCHES CLOSE TOGETHER.

Fig. 7

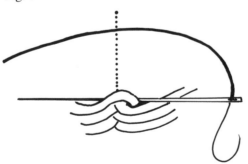

PACK THE CORNER STITCHES BY DIGGING THE NEEDLE BELOW THE PREVIOUS ROW.

Fig. 8

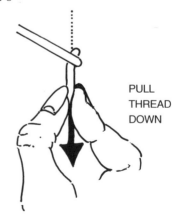

PULL THREAD DOWN

THEN PULL THE THREAD OF THE STITCH JUST TAKEN STRAIGHT DOWN into the corner. This will keep the stitches close together.
The next row will hold down the last row.

Fig. 9

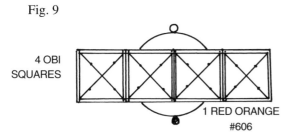

4 OBI
SQUARES

1 RED ORANGE
#606

The 4 Obi Squares and Bands will be completed first, then the North and South Pole Squares.

Fig. 10

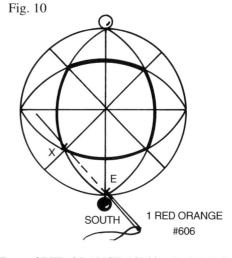

X

E

SOUTH

1 RED ORANGE
#606

Do 1 Row of RED ORANGE #606 just INSIDE the Gold Mark Lines in the 4 squares around the Obi.

Fig. 11

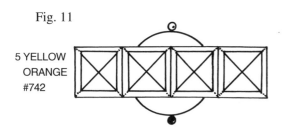

5 YELLOW
ORANGE
#742

Do 5 Rows of YELLOW ORANGE #741 INSIDE the Red Orange #606 row on all 4 squares around the Obi.

The TOTAL PATTERN:

Fig. 12

The pattern continues with:

 3 Rows RED ORANGE #606
 2 Rows YELLOW ORANGE #741
 9 Rows RED ORANGE #606 (Pack them!)
 1 Row GOLD Balger Ombre #2000.

REPEAT this pattern in ALL 4 SQUARES AROUND THE OBI.

1 RED ORANGE #606
5 YELLOW ORANGE #741
3 RED ORANGE #606
2 YELLOW ORANGE #741
9 RED ORANGE #606
1 GOLD #2000

1/2 MARK PIN

Fig. 13

16 PAPER TABS

1/2 inch
(1.2 cm)

1 1/4 inch
(3 cm)

BANDS interweave horizontally over and under the sides of the 4 squares.
CUT 16 Paper Tabs 1 1/4 inch by 1/2 inch.

Fig. 14

OBI

OBI

Place the Paper Tabs in the 4 squares as in Figure 14. Tabs go between the pattern threads and the surface wrap threads.

Fig. 15

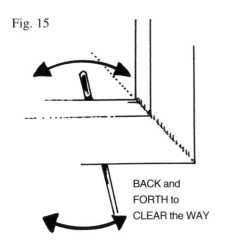

BACK and
FORTH to
CLEAR the WAY

Be careful NOT TO CATCH SURFACE WRAP
THREADS ON TOP OF the PAPER TABS.
Use your needle to clear the way. Slide it, eye-end first,
under the design threads.
Then slide the paper under the needle.

Fig. 16

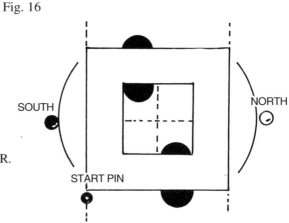

SOUTH

NORTH

START PIN

TO WRAP THE CENTER BANDS:

All colored band threads will be pre-measured and
threaded into the needle for "ENTER," "EXIT,"
and "ESCAPE." The eye-end of the needle pushes
thread between pattern threads and paper tabs.

Work from the LEFT of the space toward the CENTER.

Place a START PIN at one LOWER LEFT
CORNER.

Hold the ball with the NORTH POLE on the
RIGHT, SOUTH POLE on the LEFT (horizontally).

Fig. 17

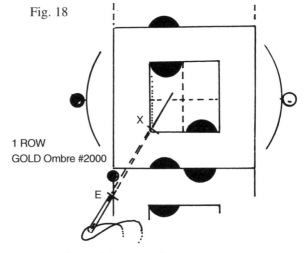

1 WRAP + 4 inches

GOLD Ombre #2000

Measure and cut 1 wrap plus 4 inches of GOLD
Ombre #2000.

Fig. 18

1 ROW
GOLD Ombre #2000

Do 1 Row of GOLD #2000.
ENTER to EXIT at the LOWER LEFT CORNER.

Using the needle, eye-end first, work the thread
under and over the sides of the squares.
END where you BEGAN.
EXIT and ESCAPE.

70

Fig. 19

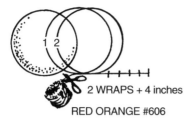

2 WRAPS + 4 inches
RED ORANGE #606

Measure and cut 2 wraps plus 4 inches of RED
ORANGE #606.

Thread needle.

Fig. 20

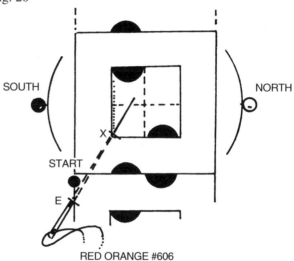

SOUTH

NORTH

X

START

E

RED ORANGE #606

ENTER to EXIT at the START CORNER,
immediately to the RIGHT of the GOLD Row.

WORK FROM THE LEFT TOWARD THE
CENTER.

Fig. 21

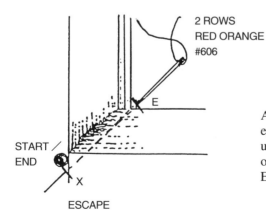

2 ROWS
RED ORANGE
#606

E

START /
END

X

ESCAPE

Apply the RED ORANGE #606 using the needle
eye-end first, using the tabs to interweave over and
under the sides of the squares. Wrap on the 2 wraps
of RED ORANGE #606.
EXIT AND ESCAPE.

To continue, MEASURE and CUT the thread
EACH TIME. Thread the needle.
ENTER to EXIT just INSIDE the last row.
INTERWEAVE the rows around the ball.

Fig. 22

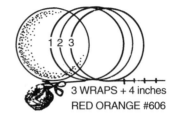

5 WRAPS + 4 inches
YELLOW ORANGE #741

YELLOW ORANGE #741
Measure and cut 5 wraps plus 4 inches. Apply.

Fig. 23

3 WRAPS + 4 inches
RED ORANGE #606

RED ORANGE #606
Measure and cut 3 wraps plus 4 inches. Apply.

Fig. 24

2 WRAPS + 4 inches
YELLOW ORANGE #741

YELLOW ORANGE #741
Measure and cut 2 wraps plus 4 inches. Apply.

Fig. 25

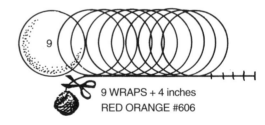

9 WRAPS + 4 inches
RED ORANGE #606

RED ORANGE #606
Measure and cut 9 wraps plus 4 inches. Apply.

Fig. 26

THE COMPLETED BAND

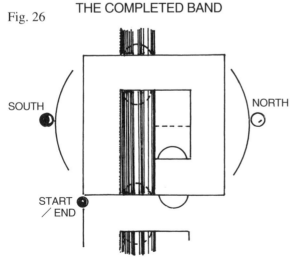

SOUTH

NORTH

START
/ END

THE BAND ROWS COMPLETE from the
BEGINNING STARTING LEFT to CENTER:

1 Row GOLD Balger Ombre #2000
2 Rows RED ORANGE #606
5 Rows YELLOW ORANGE #741
3 Rows RED ORANGE #606
2 Rows YELLOW ORANGE #741
9 Rows RED ORANGE #606.

To do BAND 2,
TURN the ball so the NORTH POLE is on the LEFT, SOUTH POLE is on the RIGHT.

Again work from LEFT to CENTER.

Fig. 27

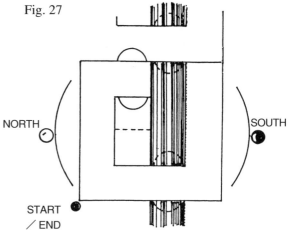

NORTH

SOUTH

START
╱ END

Fig. 28

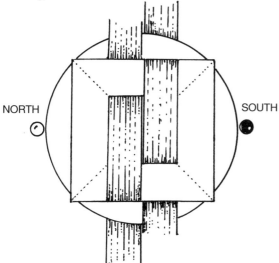

NORTH

SOUTH

REPEAT the pattern on the LEFT HALF (second side).

1 Row GOLD Balger Ombre #2000.
2 Rows RED ORANGE #606.
5 Rows YELLOW ORANGE #741.
3 Rows RED ORANGE #606.
2 Rows YELLOW ORANGE #741.
9 Rows RED ORANGE #606.

Fig. 29

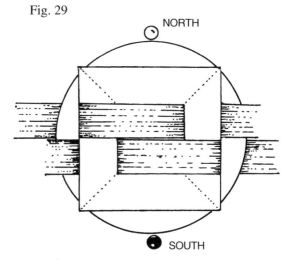

NORTH

SOUTH

Turn the ball so the NORTH POLE is at the TOP.

Complete the STITCHED SQUARE around the NORTH POLE. Use the identical pattern.

Fig. 30

NORTH and SOUTH

STITCHED
SQUARES

REPEAT the STITCHED SQUARE around the SOUTH POLE.

Fig. 31

BAND 1

GOLD
#2000

E

NORTH

X

ENTER in the CENTER space to EXIT at the
LOWER LEFT CORNER.
Pull thread through, disappear knot.
Use a START PIN.
BEGIN by going OVER.
Use the eye-end of the needle to interweave rows
through tabs and pattern threads.

Work from LEFT to CENTER.

END where you BEGAN.

Complete Band #1.

Fig. 32

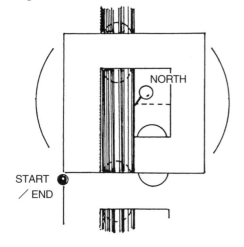

NORTH

START
/ END

1 Row GOLD Balger Ombre #2000.
2 Rows RED ORANGE #606.
5 Rows YELLOW ORANGE #741.
3 Rows RED ORANGE #606.
2 Rows YELLOW ORANGE #741.
9 Rows RED ORANGE #606.

Fig. 33

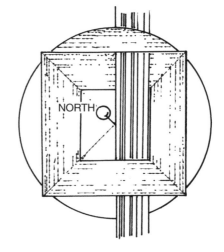

NORTH

TURN the ball:
 NORTH POLE TOP,
 BAND on the RIGHT.

Fig. 34

BAND 2

Complete Band #2 in the LEFT SIDE SPACE.

1 Row GOLD Balger Ombre #2000.
2 Rows RED ORANGE #606.
5 Rows YELLOW ORANGE #741.
3 Rows RED ORANGE #606.
2 Rows YELLOW ORANGE #741.
9 Rows RED ORANGE #606.

74

Fig. 35

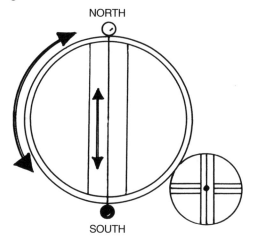

NORTH

SOUTH

Final Bands interweave AROUND NORTH to SOUTH.

Fig. 36

Place Paper Tabs for the FIRST 2 BANDS using Figure 36.

12 Tabs total in all 4 squares are placed in the
 UPPER LEFT QUARTER and
 LOWER RIGHT QUARTER in
ALL 4 SQUARES (8 total under squares).

4 more tabs are placed in spaces with Bands,
 UNDER the Bands, in
 LOWER LEFT and
 UPPER RIGHT corners.

Hold the ball with the NORTH POLE at the TOP, TABS at UPPER LEFT and LOWER RIGHT as in Figure 36.

Fig. 37

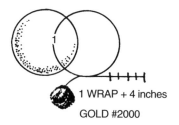

1 WRAP + 4 inches
GOLD #2000

Measure GOLD metallic #2000
1 WRAP plus 4 inches.

Thread needle.

Knot the end.

75

With the NORTH POLE at the TOP, turn the ball 1/4 turn.
There are 2 bands remaining to be completed.

Place Paper Tabs, some are already in place.

Tabs should be located under pattern threads alternating LEFT, RIGHT, LEFT, RIGHT, like footprints, ALL the way AROUND the ball from North to South and back to North.

Again work from LEFT to CENTER.
REPEAT the Band pattern.

Fig. 38

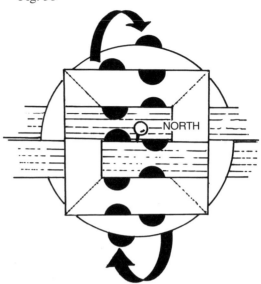

Fig. 39

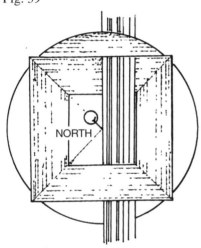

TURN the ball so the completed Band is on the RIGHT.

Fig. 40

In the LEFT side space, complete the last Band from LEFT to CENTER.

 1 Row GOLD Balger Ombre #2000.
 2 Rows RED ORANGE #606.
 5 Rows YELLOW ORANGE #741.
 3 Rows RED ORANGE #606.
 2 Rows YELLOW ORANGE #741.
 9 Rows RED ORANGE #606.

Remove the paper tabs only if they show.

The ball is complete.

WINTER PINES

This ball uses a new division technique called "Double Double Eighths" and the "Kiku" or "Chrysanthemum" stitch to provide its unique snowflake effect.

MATERIALS:

4-inch ball—Forest Green thread wrap to match
 DMC #890(Forest Green)
DMC Pearl Cotton #5 in 2 colors:
 Forest Green #890
 White #005
DMC 6-strand Embroidery Floss White #005
Kreinik's Fine Braid #8 SILVER #001
 and Very Fine Braid #4 SILVER #001
Marking Thread—DMC Pearl Cotton #5 Forest Green #890

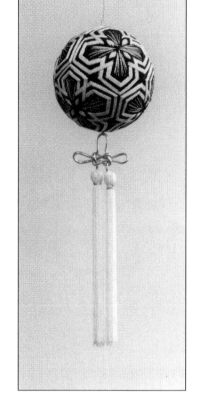

Fig. 1

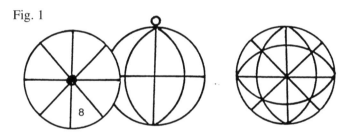

DIVIDE the ball into 8ths and DOUBLE EIGHTHS.

Fig. 2

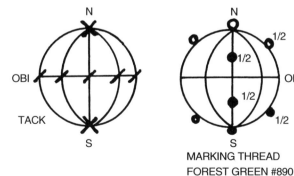

MARKING THREAD
FOREST GREEN #890

Fig. 3

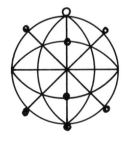

DO NOT REMOVE
MARK PINS

MARK the ball with DMC Pearl Cotton #5 FOREST GREEN #890.
TACK the NORTH POLE, SOUTH POLE and OBI Line intersections.

DO NOT REMOVE the 1/2 MARK PINS, "Double Double Eighths" mark will use these same 1/2 Mark pins and the in-between divisions around the Obi.

DOUBLE DOUBLE EIGHTHS MARK: Fig. 4

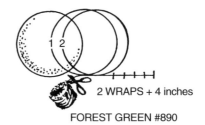

MEASURE 2 Wraps plus 4 inches of FOREST
GREEN #890 DMC #5.
Thread your needle.

2 WRAPS + 4 inches

FOREST GREEN #890

Fig. 5

2 DIAGONAL WRAPS will be made using
the 2 mark pins as your guide.

Use the IN-BETWEEN divisions around the Obi
Line. Use the SAME 1/2 MARK PINS.

ENTER your needle to EXIT at an IN-BETWEEN
division on the Obi line.

Fig. 6

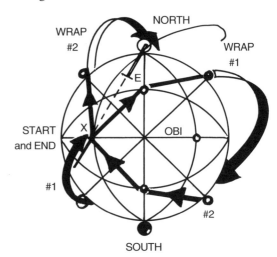

Wrap INSIDE the 2 mark pins (toward the Pole).

Wrap once to the LEFT,
wrap once to the RIGHT.
END where you BEGAN.
EXIT and ESCAPE.
TACK the 2 Obi Line intersections.

TURN the ball 1/4 turn. REPEAT.

The mark is complete.

There is now a square inside a square diagonally.

Fig. 7

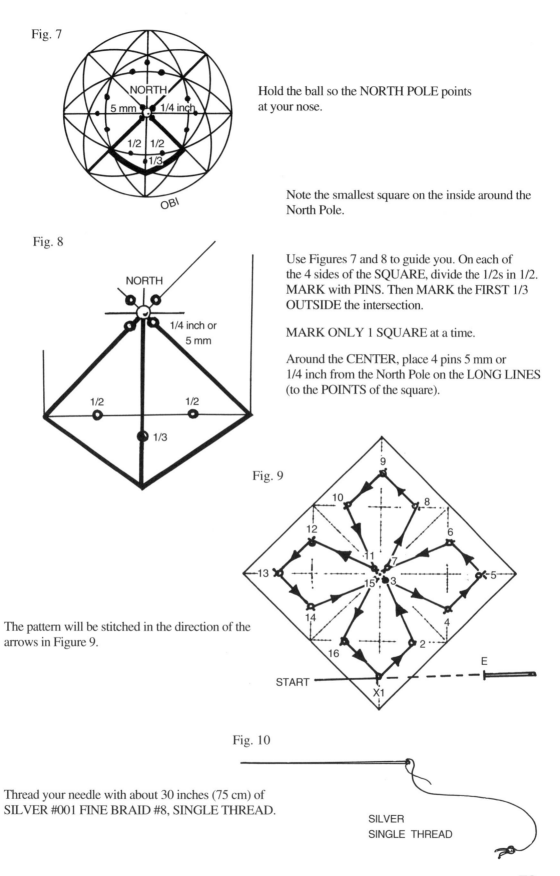

NORTH

5 mm 1/4 inch

1/2 1/2

1/3

OBI

Hold the ball so the NORTH POLE points
at your nose.

Note the smallest square on the inside around the
North Pole.

Fig. 8

NORTH

1/4 inch or
5 mm

1/2 1/2

1/3

Use Figures 7 and 8 to guide you. On each of
the 4 sides of the SQUARE, divide the 1/2s in 1/2.
MARK with PINS. Then MARK the FIRST 1/3
OUTSIDE the intersection.

MARK ONLY 1 SQUARE at a time.

Around the CENTER, place 4 pins 5 mm or
1/4 inch from the North Pole on the LONG LINES
(to the POINTS of the square).

Fig. 9

9
10 8
12 6
13 11 7 5
15 3
14 4
16 2
START
X1
E

The pattern will be stitched in the direction of the
arrows in Figure 9.

Fig. 10

Thread your needle with about 30 inches (75 cm) of
SILVER #001 FINE BRAID #8, SINGLE THREAD.

SILVER
SINGLE THREAD

79

Fig. 11

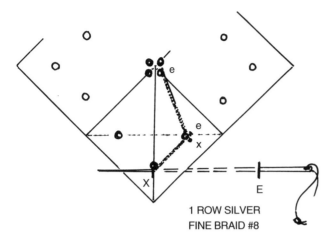

ENTER to EXIT at the bottom OUTER POINT of
the pattern. Stitches go COUNTER-CLOCKWISE.
Take stitches at the BOTTOM of the pattern.
Turn the ball with each stitch.

REMOVE each MARK PIN as you take the stitch.

1 ROW SILVER
FINE BRAID #8

Do 1 Row of SILVER Fine Braid #8 (001).

END where you BEGAN.

Fig. 12

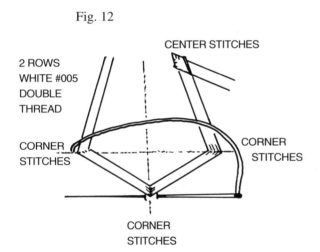

2 ROWS
WHITE #005
DOUBLE
THREAD

CENTER STITCHES

CORNER
STITCHES

CORNER
STITCHES

CORNER
STITCHES

With WHITE #005 DMC Pearl Cotton #5,
DOUBLE THREAD, thread a long double length
into your needle.

OUTSIDE the SILVER Fine Braid #8 (001),
do 2 Rows with DOUBLE THREAD of DMC
Pearl Cotton #5 WHITE #005.
MITER the CORNERS.

Keep CORNER stitches and CENTER stitches
immediately beneath the last, very tight together.
NO SPACE IN BETWEEN.

END where you BEGAN.

Fig. 13 CENTER STITCHES Fig. 14

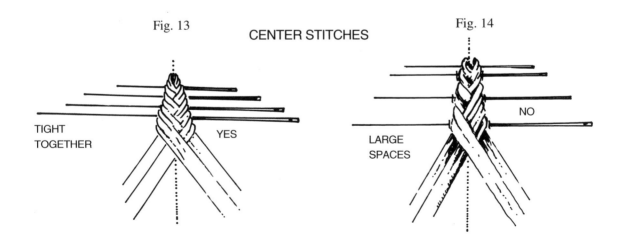

TIGHT
TOGETHER

YES

LARGE
SPACES

NO

Fig. 15

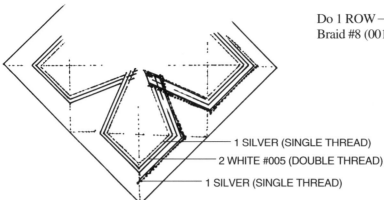

Do 1 ROW—SINGLE Thread, of SILVER Fine Braid #8 (001) outside the WHITE DMC #005.

— 1 SILVER (SINGLE THREAD)
— 2 WHITE #005 (DOUBLE THREAD)
— 1 SILVER (SINGLE THREAD)

Fig. 16

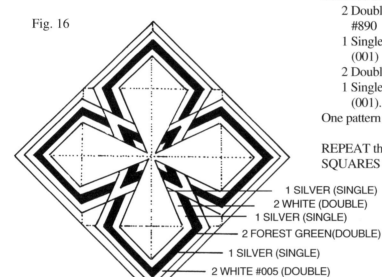

1 SILVER (SINGLE)
2 WHITE (DOUBLE)
1 SILVER (SINGLE)
2 FOREST GREEN(DOUBLE)
1 SILVER (SINGLE)
2 WHITE #005 (DOUBLE)
1 SILVER (SINGLE)

Continue the pattern with:
 2 Double thread Rows—FOREST GREEN #890
 1 Single thread Row—SILVER Fine Braid #8 (001)
 2 Double thread Rows—WHITE #005
 1 Single thread Row—SILVER Fine Braid #8 (001).

One pattern is complete.

REPEAT the pattern identically in ALL 6 SQUARES of the Double Eighths Mark.

Fig. 17

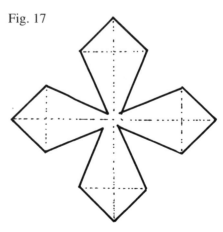

The CENTER SECTIONS

PINE NEEDLES:

In each Center Section, "Pine Needles" fill in the 4 quarters.
Each quarter is done separately.
Stitches radiate from the center each time but DO NOT CROSS THROUGH THE CENTER.

Pine Needle stitches use

 1 SINGLE thread of SILVER Very Fine Braid #4 (001)
 2 STRANDS of WHITE #005
 6-strand Embroidery Floss.

81

Fig. 18

"PINE NEEDLE"
STITCH

In each quarter of the Center Section, radiate 4 or 5 stitches from the center with SILVER Very Fine Braid #4 (001).

4-5 ROWS
SILVER #4
VERY FINE BRAID

With WHITE #005 DMC 6-strand Embroidery Floss, use 2 STRANDS of the 6.

Fig. 19

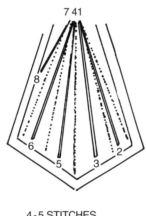

4-5 STITCHES
WHITE #005
EMBROIDERY FLOSS

Fig. 20

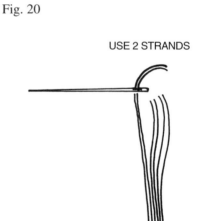

USE 2 STRANDS

Among the SILVER Pine Needles in each quarter, do 4 or 5 WHITE #005 stitches of 2 strands.

REPEAT the Pine Needles in ALL 6 CENTERS.

The ball is complete.

82

The Pentagons Mark

Pentagons
Mark Symbol

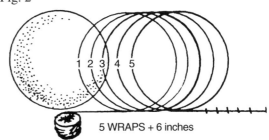

Fig. 1

Divide into 10ths around OBI.

Fig. 2

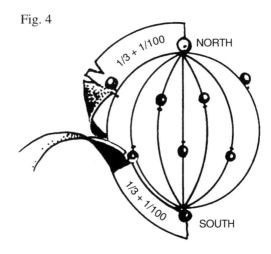

1 2 3 4 5

5 WRAPS + 6 inches

MEASURE 5 WRAPS plus 6 inches of marking thread.

Fig. 3

NORTH

1/3

1/3

OBI LINE:
PINS ONLY

SOUTH

MARK the 10ths with thread.

DO NOT MARK THE OBI LINE WITH THREAD.
Use pins only.
DIVIDE into 1/3s between NORTH and SOUTH POLES.

Fig. 4

1/3 + 1/100

NORTH

1/3 + 1/100

SOUTH

WITH PINS, mark upper 1/3 and lower 1/3 on alternating lines.
ADD 1/100 of the circumference more to EACH 1/3 toward the OBI LINE.
(* see NOTE below.)

* NOTE : The 1/100 measurement is found by measuring the total distance around the ball (circumference) with your centimeter tape. Divide the total by 100. This extra added bit to each 1/3 makes the pentagon divisions more accurate. Don't ask me why.

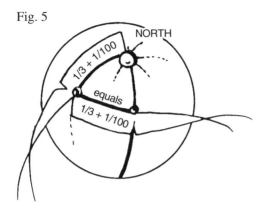

Fig. 5

1/3 measurements are EQUAL IN ALL
DIRECTIONS. CHECK them for accuracy.

Fig. 6

CUT 10 PAPER tabs.
MARK the UPPER 1/3s with NUMBERS.

MARK the LOWER 1/3s with LETTERS.

Fig. 7

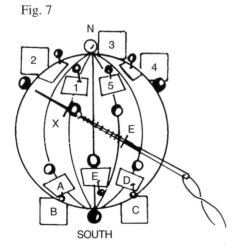

Place tabs COUNTER-CLOCKWISE.

84

Fig. 8

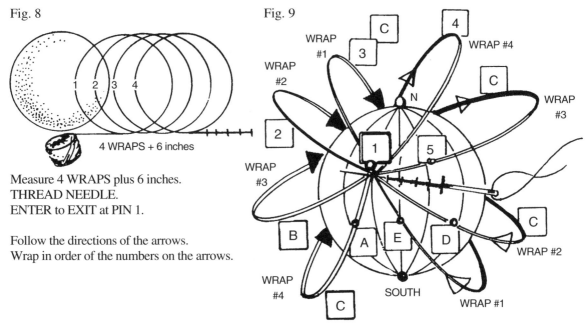

4 WRAPS + 6 inches

Measure 4 WRAPS plus 6 inches.
THREAD NEEDLE.
ENTER to EXIT at PIN 1.

Follow the directions of the arrows.
Wrap in order of the numbers on the arrows.

Fig. 9

Follow WRAP NUMBER 1 from PIN #1,
around the ball to 3, to C, to E, back to 1.
WRAP NUMBER 2: 1 — 2 — C — D — 1
WRAP NUMBER 3: 1 — B — C — 5 — 1
WRAP NUMBER 4: 1 — A — C — 4 — 1
ESCAPE.
DO NOT TACK YET.

Fig. 10

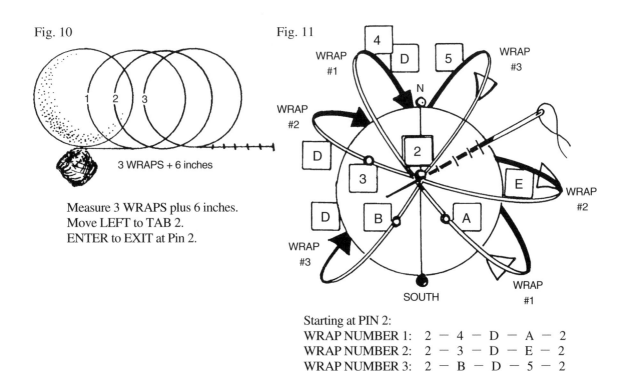

3 WRAPS + 6 inches

Measure 3 WRAPS plus 6 inches.
Move LEFT to TAB 2.
ENTER to EXIT at Pin 2.

Fig. 11

Starting at PIN 2:
WRAP NUMBER 1: 2 — 4 — D — A — 2
WRAP NUMBER 2: 2 — 3 — D — E — 2
WRAP NUMBER 3: 2 — B — D — 5 — 2
ESCAPE, DO NOT TACK YET.

Fig. 12

2 WRAPS + 6 inches

Measure 2 WRAPS plus 6 inches.

Fig. 13

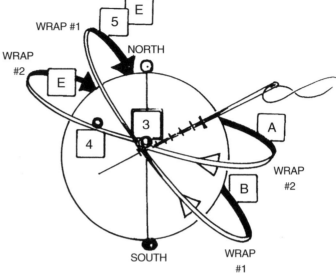

ENTER to EXIT at PIN 3.

WRAP NUMBER 1: 3 — 5 — E — B — 3
WRAP NUMBER 2: 3 — 4 — E — A — 3
ESCAPE, DO NOT TACK.

Fig. 14

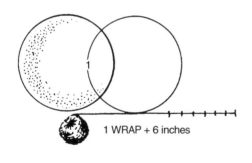

1 WRAP + 6 inches

Measure 1 WRAP plus 6 inches.

BEFORE YOU TACK:

ADJUST THREADS to make regular shapes.
CHECK PENTAGON CENTERS.
ADJUST LINES.
TACK ALL 12 Pentagon Centers.
The mark is complete.

Fig. 15

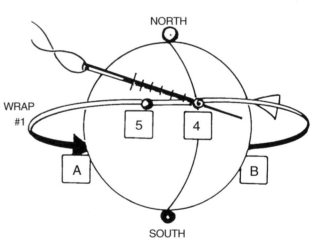

ENTER to EXIT at PIN 4.

FINAL WRAP TO COMPLETE:
4 — 5 — A — B — 4.

MORNING GLORIES

Called "Asagao" in Japan, this design is a symbolic floral pattern using the hexagon-shaped flower and its trailing vine.

The pattern is applied in layers, first the morning glories, then the leaves surrounding, then center stars, then the trailing vines.

A simple, enjoyable pattern, this can become many personalities when different color combinations are used.

MATERIALS:

3-inch ball — Yellow thread wrap
DMC Pearl Cotton #5 in 6 colors:
>Purple #550
>Aqua #598
>2 Greens — Christmas Green #909
>>Light Green #703
>Royal Blue #797
>Navy Blue #939
Marking Thread — GOLD Kreinik's Balger Ombre #2000

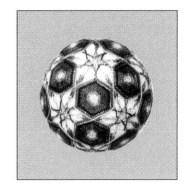

Fig. 1

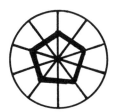

DIVIDE the ball into PENTAGONS.

MARK with GOLD Balger Ombre #2000.

TACK the Pentagon CENTERS.

Fig. 2

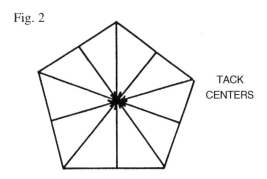

TACK
CENTERS

LAYER 1 — Morning Glories

At all 5 POINTS around each pentagon, a filled-in HEXAGON (6 sides) will be stitched.
The intersections of the 3 threads in the TRIANGLE CENTERS make the HEXAGONS.

Fig. 3

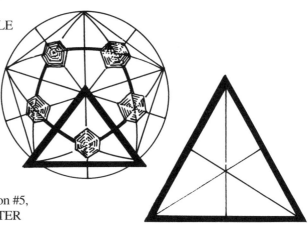

With AQUA BLUE #598 DMC Pearl Cotton #5, single thread, ENTER to EXIT in the CENTER of a TRIANGLE.

Fig. 4

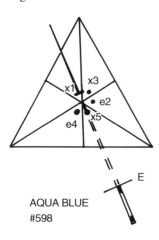

AQUA BLUE
#598

Fig. 5

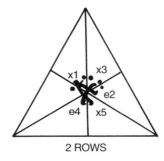

2 ROWS

Fig. 6

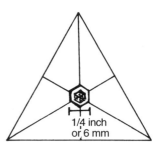

1/4 inch
or 6 mm

A completed AQUA BLUE CENTER should measure 1/4 inch or 6 mm in diameter.

Fig. 7

Stitch 2 ROWS of AQUA BLUE #598 around the CENTERS of ALL TRIANGLES all over the ball.

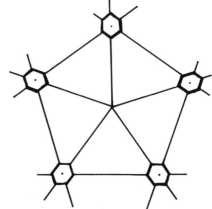

Around each AQUA BLUE CENTER,
stitch 2 Rows of ROYAL BLUE #797.
Use a SINGLE THREAD.
Around the ROYAL BLUE, stitch 5 Rows of
PURPLE #550, SINGLE THREAD.

Around all HEXAGONS, stitch 2 Rows of
NAVY BLUE #939, SINGLE THREAD.

Fig. 8

1 inch
or
2.5 cm

2 AQUA BLUE #598
2 ROYAL BLUE #797
5 PURPLE #550
2 NAVY BLUE #939

The finished morning glories measure approximately
1 inch or 2.5 cm in diameter, point to point.

LAYER 2 — The Leaves

With GOLD Balger Ombre #2000, SINGLE
THREAD, stitch a STAR inside each pentagon.

Use the pentagons' sides as your guides.
The STAR POINTS' stitch is taken 1/2 way up the
GOLD MARK LINE toward the CENTERS of the
surrounding pentagons as in Figure 9.

Use the "Kiku" or "Chrysanthemum" Stitch.

Fig. 9

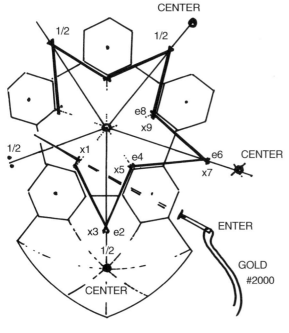

Fig. 10

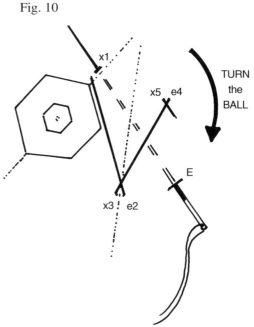

Hold the ball so the STITCH is taken at the
BOTTOM POINT of the STAR pattern.

TURN the PATTERN CLOCKWISE in order to
take each stitch at the BOTTOM of the pattern.

89

Fig. 11

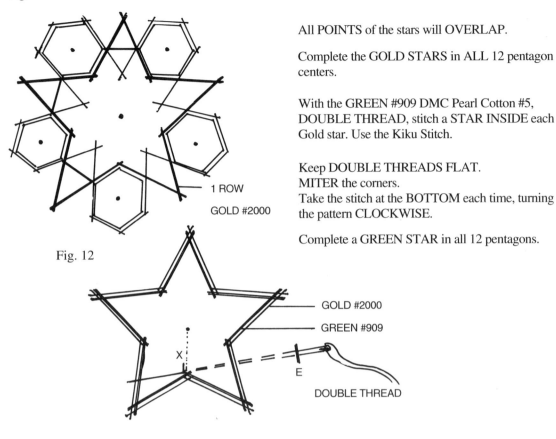

1 ROW

GOLD #2000

All POINTS of the stars will OVERLAP.

Complete the GOLD STARS in ALL 12 pentagon centers.

With the GREEN #909 DMC Pearl Cotton #5, DOUBLE THREAD, stitch a STAR INSIDE each Gold star. Use the Kiku Stitch.

Keep DOUBLE THREADS FLAT.
MITER the corners.
Take the stitch at the BOTTOM each time, turning the pattern CLOCKWISE.

Complete a GREEN STAR in all 12 pentagons.

Fig. 12

GOLD #2000

GREEN #909

X

E

DOUBLE THREAD

Fig. 13

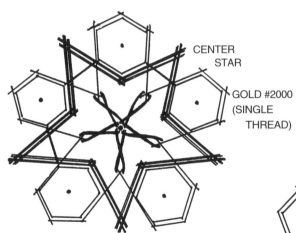

CENTER
STAR

GOLD #2000
(SINGLE
THREAD)

LAYER 3 — The Center Stars

With GOLD Balger Ombre #2000, stitch a STAR in the CENTER of each pentagon.
Use a SINGLE THREAD.

With your CENTER STAR POINTS, CONNECT the OVERLAP STAR POINTS from the 5 GREEN STARS outside.

Fig. 14

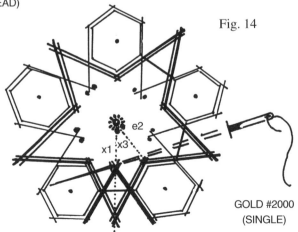

e2

x1 x3

GOLD #2000
(SINGLE)

To begin, ENTER to EXIT at the LEFT of the BOTTOM Green point inside the center space.

Use the Kiku Stitch.

Hold the ball so that the stitch is taken at the
BOTTOM POINT of the star pattern.

Take the CENTER STITCHES immediately
NEXT TO THE CENTER TACK stitches
of each pentagon.

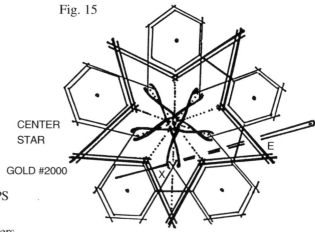

Fig. 15

CENTER
STAR

GOLD #2000

Take the POINT STITCHES UNDER THE TIPS
of the GREEN STAR POINTS.

Stitch a Gold Center Star in all 12 pentagon centers.

Over the Gold Center Stars, stitch a GREEN STAR
on the ALTERNATING MARK LINES (star points
touch HEXAGON POINTS).

Use the GREEN #909, SINGLE THREAD.

Stitch a Green Center Star in all 12 pentagon
centers.

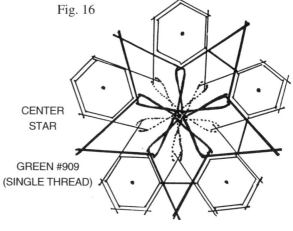

Fig. 16

CENTER
STAR

GREEN #909
(SINGLE THREAD)

Fig. 17

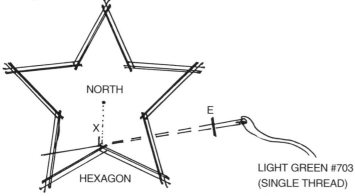

NORTH

X

HEXAGON

E

LIGHT GREEN #703
(SINGLE THREAD)

Fig. 18

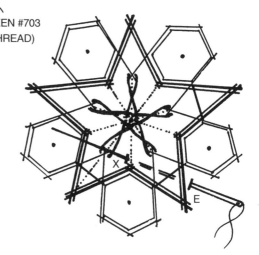

LAYER 4 — The Trailing Vines

Thread your needle with a long length, SINGLE
THREAD, of LIGHT GREEN #703.

At the NORTH POLE PENTAGON, ENTER to
EXIT at a HEXAGON POINT that points to the
North Pole pin, BETWEEN the INSIDE STAR and
OUTSIDE STAR.

Using TOP POINTS and BOTTOM POINTS of
HEXAGONS, stitch a ZIG ZAG, continuing in the
SAME LINE around the ball.
END where you BEGAN.

Use a MARK PIN to keep your place.

Fig. 19

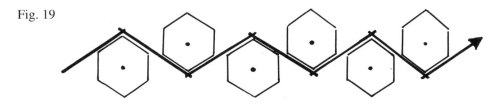

Fig. 20

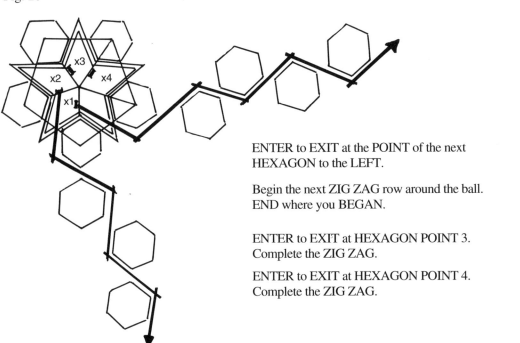

ENTER to EXIT at the POINT of the next
HEXAGON to the LEFT.

Begin the next ZIG ZAG row around the ball.
END where you BEGAN.

ENTER to EXIT at HEXAGON POINT 3.
Complete the ZIG ZAG.

ENTER to EXIT at HEXAGON POINT 4.
Complete the ZIG ZAG.

Now turn the ball. You will see ONE ROW that
REMAINS UNDONE.

Fig. 21

ENTER to EXIT at any INCOMPLETE
HEXAGON POINT that POINTS TO CENTER.
Continue the ZIG ZAG around until you END
where you BEGAN.
EXIT and ESCAPE.

The ball is complete.

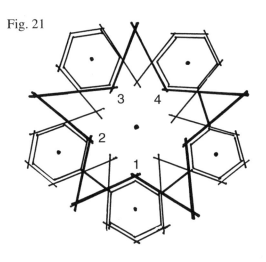

CRYSTAL STAR

This very old traditional pattern uses "Mitsubishi" (Triple Diamonds) to create its stars. The pattern is applied in two stages, each a separate layer of the design.

In antique fashion, it uses fine thread and in modern combination, woven metallic ribbon.

It's a wonderfully fascinating adventure in design.

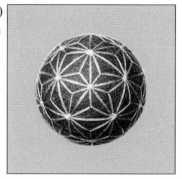

MATERIALS:

4-inch ball wrapped in Deep Emerald Green, 2 shades darker than DMC #958. Locate your pattern threads first, then locate your wrap thread.

Trolley Needle or Laying Tool (any large dull-pointed needle will do)

Bunka Brush (Nap Raiser) — to comb out the 6-strand (a tooth brush or flea comb will do)

2 skeins DMC 6-strand Embroidery Floss — Medium Emerald Green #958

2 spools Kreinik's Balger 1/16 inch Ribbon — Turquoise #029

1 spool Kreinik's Balger 1/16 inch Ribbon — Gold #002J

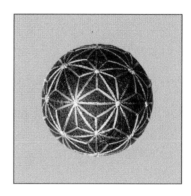

Fig. 2

DIVIDE the ball into PENTAGONS. MARK with 2 STRANDS of the 6-strand DMC floss #958 MEDIUM EMERALD GREEN.

Fig. 1

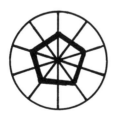

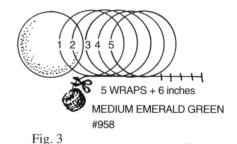

5 WRAPS + 6 inches
MEDIUM EMERALD GREEN
#958

Fig. 3

USE 2 STRANDS
MEDIUM EMERALD
GREEN #958

Begin by MEASURING 5 WRAPS plus 6 inches of DMC 6 strand #958. Separate 2 strands for the first 10 divisions, use the remainder of the thread to complete the pentagon mark.

Lightly TACK ALL 12 Pentagon CENTERS.
Some of the mark threads will be removed later.

REMOVE all PINS EXCEPT:
 WHITE — NORTH POLE
 BLACK — SOUTH POLE
and 2 Pentagon Division Paper Markers — "A" and "B."
 Place "A" Marker at the North Pole End.
 Place "B" Marker at the South Pole End.

This pattern is applied in 2 stages.

Fig. 4

TACK

CENTERS

Fig. 5

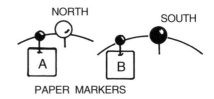

PAPER MARKERS

STAGE ONE

This portion of the design centers around the North Pole Pentagon and the South Pole Pentagon.
Use the DMC 6-strand floss MEDIUM EMERALD GREEN #958.

Start with the NORTH POLE PENTAGON.

With your CENTIMETER TAPE MEASURE, DIVIDE the SHORT LINES inside the pentagon in 1/3s.
MARK with a PIN 2/3 out from the CENTER.

Fig. 6

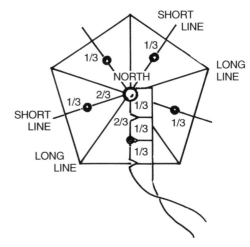

Fig. 7

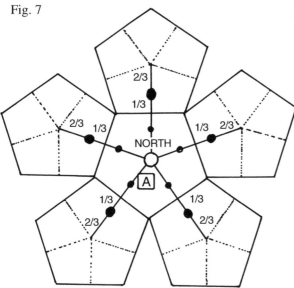

Continue on the SAME SHORT LINES into the SURROUNDING pentagons.
There are 5 pentagons around the outside.

MARK 2/3 out from CENTER on all of the SHORT LINES in ALL 5 surrounding pentagons around the NORTH POLE.

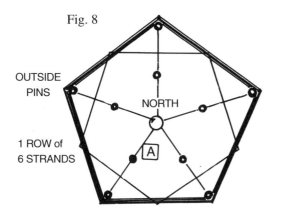

Fig. 8

OUTSIDE
PINS

NORTH

A

1 ROW of
6 STRANDS

The FIRST Row of the stitched pattern connects the 5 pins IN THE SURROUNDING PENTAGONS around the North Pole. (Figure 8).

After you place the pin markers, lay on a row of thread around the pins to CHECK THE MEASUREMENT. The row should lay JUST OUTSIDE the INTERSECTION in the MIDDLE of the TRIANGLES. (Figure 9).

CUT about 18 inches of MEDIUM EMERALD GREEN floss #958.

Before threading your needle, comb out the 6 strands with the Bunka Brush or tooth brush. Wrap one end around a left hand finger to secure. Use the brush to untangle the threads. They will be applied so they lie flat, side-by-side (untwisted), on the ball.

After Enter and Exit, the TROLLEY NEEDLE will be used on the thumb of the Left Hand, or use the Laying Tool. Run it back and forth under the 6 strands to flatten and align them.

The thread will be laid in place at the Mark Pin, held in place with the Left Hand, the stitch taken under the mark thread with the Right Hand.

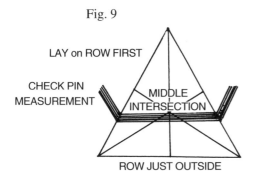

Fig. 9

LAY on ROW FIRST

CHECK PIN
MEASUREMENT

MIDDLE
INTERSECTION

ROW JUST OUTSIDE

Now thread your needle with the EMERALD GREEN Floss #958. KNOT the END.

Start at the OUTSIDE PIN at the TOP of the pattern. Connect the 5 OUTSIDE PINS with 1 ROW of 6 strand floss. (Figure 10).
TURN the BALL.
Take each stitch at the TOP OF THE PATTERN.

Fig. 10

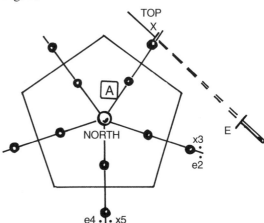

TOP
X

A

NORTH

x3
e2

E

e4 • | • x5

TURN THE BALL so the stitch is taken at the TOP each time.

REMOVE the MARK PIN after each stitch is taken.

Fig. 11

TURN
the
BALL

TOP

NORTH

A

REMOVE
the
PIN

START

Fig. 12

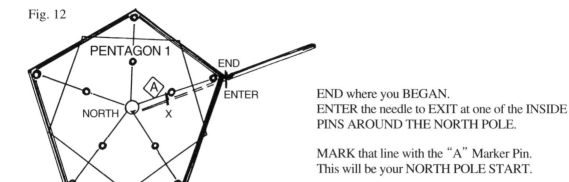

END where you BEGAN.
ENTER the needle to EXIT at one of the INSIDE PINS AROUND THE NORTH POLE.

MARK that line with the "A" Marker Pin.
This will be your NORTH POLE START.

Fig. 13

Follow the "A" LINE down to the CENTER of its connecting pentagon.
Now USE THIS as CENTER.
DIVIDE the SHORT LINES OUTSIDE this pentagon.

MARK with pins 2/3 out from the CENTERS of the surrounding pentagons.

NO INSIDE PINS are needed. Inside Pins are marked only around the North and South Poles.

Again connect the OUTSIDE PINS with 1 ROW of 6 strand floss EMERALD GREEN #958.
At the END, ENTER to EXIT at the next INSIDE PIN to the LEFT around the North Pole.

Fig. 14

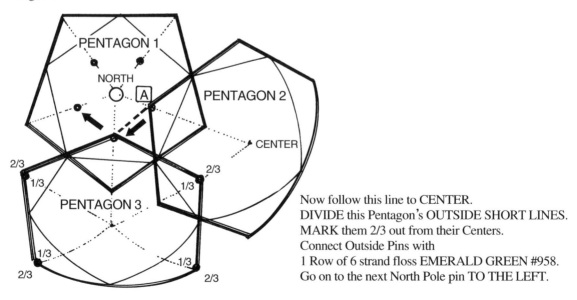

Now follow this line to CENTER.
DIVIDE this Pentagon's OUTSIDE SHORT LINES.
MARK them 2/3 out from their Centers.
Connect Outside Pins with
1 Row of 6 strand floss EMERALD GREEN #958.
Go on to the next North Pole pin TO THE LEFT.

Fig. 15

REPEAT the Pentagons using the REMAINING
PINS around the North Pole as their TOP STARTS.
Do 1 Row of 6 strand floss around each.

There are 6 NORTH POLE PENTAGONS
 and 6 SOUTH POLE PENTAGONS.

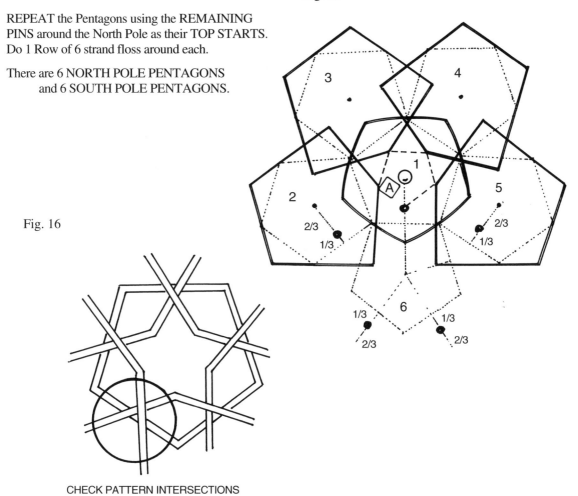

Fig. 16

CHECK PATTERN INTERSECTIONS

Fig. 17

YES NO

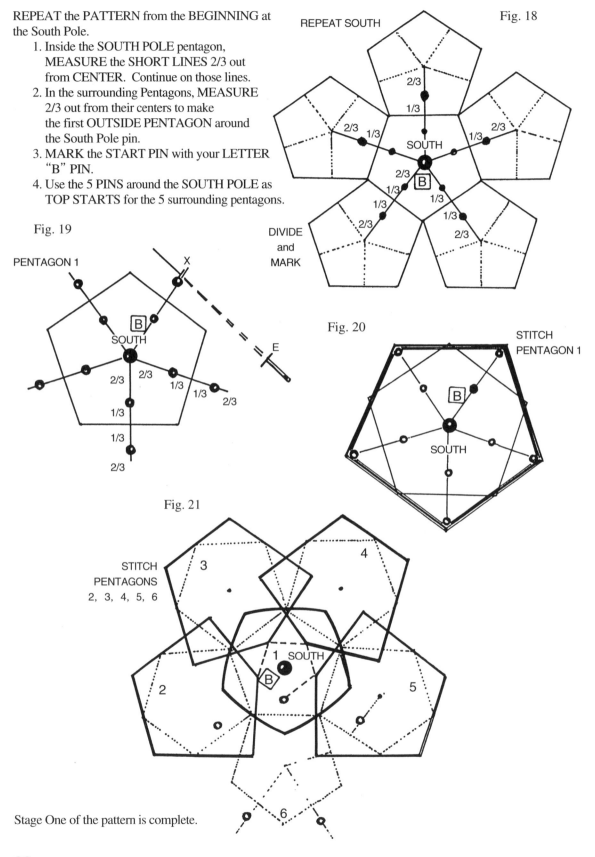

REPEAT the PATTERN from the BEGINNING at the South Pole.

1. Inside the SOUTH POLE pentagon, MEASURE the SHORT LINES 2/3 out from CENTER. Continue on those lines.
2. In the surrounding Pentagons, MEASURE 2/3 out from their centers to make the first OUTSIDE PENTAGON around the South Pole pin.
3. MARK the START PIN with your LETTER "B" PIN.
4. Use the 5 PINS around the SOUTH POLE as TOP STARTS for the 5 surrounding pentagons.

REPEAT SOUTH

Fig. 18

2/3

1/3

2/3 1/3

SOUTH

1/3 2/3

B

2/3

1/3 1/3

1/3 1/3

2/3 2/3

DIVIDE
and
MARK

Fig. 19

PENTAGON 1

X

B

SOUTH

E

2/3 2/3

1/3 1/3

2/3

1/3

1/3

2/3

Fig. 20

STITCH
PENTAGON 1

B

SOUTH

Fig. 21

STITCH
PENTAGONS
2, 3, 4, 5, 6

3

4

1 SOUTH

B

2

5

6

Stage One of the pattern is complete.

98

STAGE TWO

Sewing the lines over the Mitsubishi and Stars:

Use the metallic TURQUOISE #029 Kreinik's Balger 1/16 inch Ribbon.

Knot the end each time you start.

Use the diagram in Figure 22 to CONNECT these UNITS ALL OVER the ball.

Fig. 22

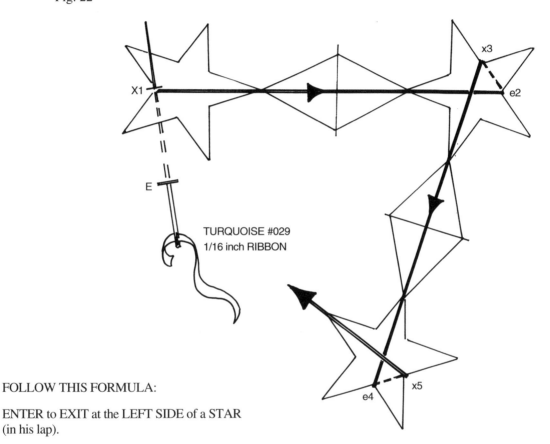

TURQUOISE #029
1/16 inch RIBBON

FOLLOW THIS FORMULA:

ENTER to EXIT at the LEFT SIDE of a STAR (in his lap).

Go straight across the MIDDLE, through the POINT of the star, toward the RIGHT.

Continue the STRAIGHT LINE through the LENGTH of the connecting DIAMOND, through the MIDDLE of the next STAR to its RIGHT SIDE LAP. Take a stitch LEFT, UNDER his wing.

EXIT on the other side using the WING as a CORNER.

Use that ANGLE to continue your line to the next diamond and star.

Continue all over the ball. Then fill in any single lines that are not completed.

Fig. 23

PATTERN CHECK:

WRONG WAY

RIGHT WAY

99

Fig. 24

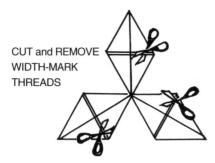

CUT and REMOVE
WIDTH-MARK
THREADS

FINISHING:

Inside all of the Mitsubishi diamond shapes are
2 STRANDS of MEDIUM EMERALD GREEN
#958 floss MARK THREADS going ACROSS the
WIDTH of each diamond (the SHORT way).

Fig. 25

With your scissors, very carefully CUT OUT these
CROSS LINES at the WIDTH of each diamond.

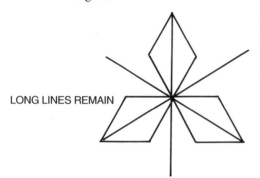

REMOVE these threads from the design so that
ONLY the long lines REMAIN.

LONG LINES REMAIN

THE CENTER DOTS:

Use the GOLD Balger 1/16 Ribbon #002J.

Like an ENLARGED TACK STITCH, stitch a
large DOT in the CENTER of EACH STAR and
MITSUBISHI all over the ball.

Fig. 26

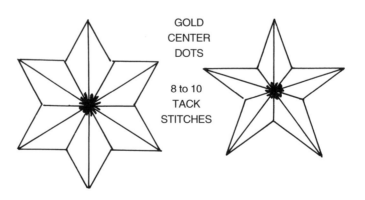

GOLD
CENTER
DOTS

8 to 10
TACK
STITCHES

The ball is complete.

100

FLAMING PEARL

This symbol of Happiness, Prosperity and Good Fortune is commonly seen in the claws of the Dragon in Oriental art.

The pattern is applied in 3 stages: triangles, then stars, then pentagons. Center star patterns can each be different or all the same. Create your own!

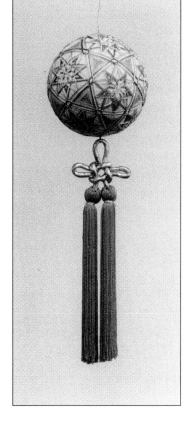

MATERIALS:

4-inch ball — Baby Pink thread wrap
DMC 6 strand Cotton Embroidery Floss in 6 colors:
Plum #327
Dark Khaki #370
Light Khaki #613
Cream #739
Melon (Orange) #3340
Marigold (Yellow-Orange) #972
Marking thread — DMC Light Gold (Spool) #282
Fil Or Clair

Fig. 1

DIVIDE the ball into PENTAGONS.

MARK with LIGHT GOLD DMC metallic #282.

Fig. 2

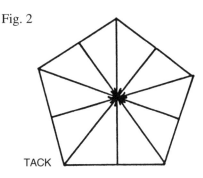

TACK

TACK the CENTER of each PENTAGON.

STAGE 1 — Triangles

Triangles of 3 colors are stitched at the points of all pentagons. The points of the pentagons are the CENTERS of the TRIANGLES.

In all triangles, use the SHORT LINES as MARK LINES.

USE 2 strands of ALL of the DMC 6 strand Embroidery Floss colors.
Begin with 2 strands of MELON #3340.
Thread your needle. Knot the thread's end.

Fig. 3

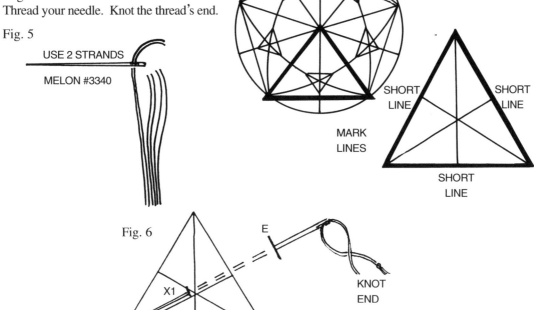

TRIANGLES

Fig. 4

SHORT LINE SHORT LINE

MARK LINES

SHORT LINE

Fig. 5

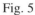

USE 2 STRANDS

MELON #3340

Fig. 6

X1

E

KNOT END

Begin in the CENTER and work OUTWARD.
Stitch a FILLED-IN TRIANGLE of 4 to 5 Rows of MELON #3340 to measure 1/2 inch (1.4 cm) on each side INSIDE ALL TRIANGLES over the ball.

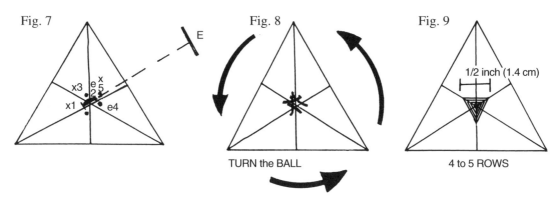

Fig. 7

E

x3 x5 e
x1 e2 e4

Fig. 8

TURN the BALL

Fig. 9

1/2 inch (1.4 cm)

4 to 5 ROWS

Fig. 10

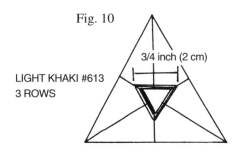

LIGHT KHAKI #613
3 ROWS

3/4 inch (2 cm)

With MARIGOLD (Yellow Orange) #972, 2 strands, do 3 ROWS around all triangles all over the ball. Each triangle now measures 3/4 inch (2 cm) on a side.

With LIGHT KHAKI #613, 2 strands, do 3 ROWS around each Melon triangle all over the ball. Each side measures 7/8 inch (2.2 cm).

Fig. 11

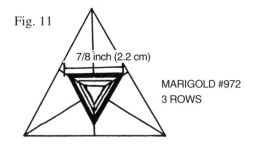

7/8 inch (2.2 cm)

MARIGOLD #972
3 ROWS

Fig. 12

USE 2 STRANDS
EACH COLOR

Each Center Star is stitched in 2 LAYERS:
 LAYER A — Stitch STAR POINTS to SIDES
 LAYER B — Stitch STAR POINTS to TRIANGLES.

STAGE 2 — Center Stars

Use the "Kiku" or "Chrysanthemum" Stitch for the Center Stars. Each can be different or all the same. Here are 6 different patterns. Place the same pattern on the pentagon opposite on the ball to cover all 12 pentagons.

Fig. 13a CENTER STARS

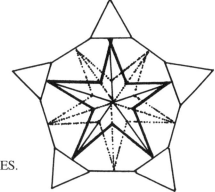

Fig. 13b

LAYER A
STAR POINTS to SIDES

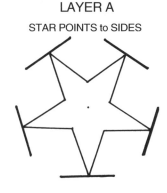

Fig. 13c

LAYER B
STAR POINTS
to TRIANGLES

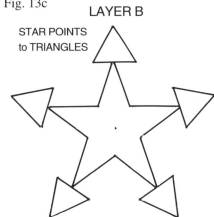

STAR #1 —LAYER A:
(Stitch STAR POINTS to SIDES)

Thread your needle with 2 strands of
LIGHT KHAKI #613. Knot the end.

ENTER to EXIT 3/4 OUT from CENTER, just
LEFT of a Mark Line to a SIDE (NO TRIANGLE).
Do 3 Rows of LIGHT KHAKI #613.
 2 Rows of CREAM #739.

To BEGIN each STAR,
ENTER to EXIT at a STAR POINT.
It's easier than starting in the center.

Align the THREADS so
they are NOT TWISTED.

Fig. 14

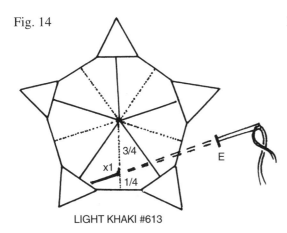

LIGHT KHAKI #613

Fig. 15

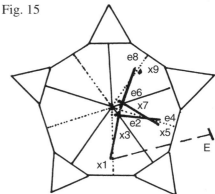

Fig. 16

LAYER A

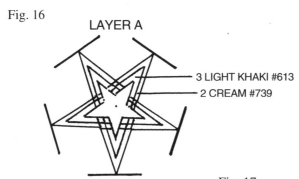

— 3 LIGHT KHAKI #613
— 2 CREAM #739

Fig. 17

LAYER B

STAR #1 —LAYER B:
(Star Points to Triangles)

ENTER to EXIT 3/4 down a Mark Line WITH A
TRIANGLE.
Do 3 Rows of CREAM #739.
 1 Row of DARK KHAKI #370.
 3 Rows of MELON #3340.

EXTEND the STAR POINTS to TOUCH the
TRIANGLES.

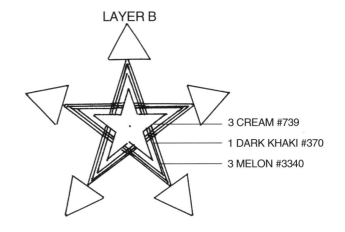

— 3 CREAM #739
— 1 DARK KHAKI #370
— 3 MELON #3340

STAR #1 —BACK to LAYER A:
(Star Points to Sides)

Do 1 Row of PLUM #327.
 1 Row — Single thread of GOLD DMC Metallic
 #282.

ENTER to EXIT below the CREAM Row.
EXTEND points to MARK LINES.

Fig. 18

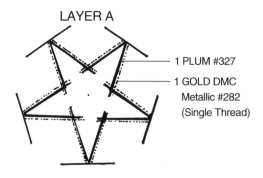

LAYER A

1 PLUM #327

1 GOLD DMC
Metallic #282
(Single Thread)

Fig. 19

LAYER B

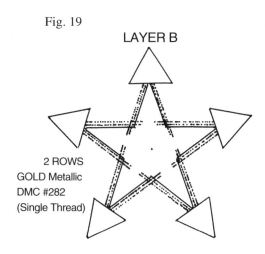

2 ROWS
GOLD Metallic
DMC #282
(Single Thread)

STAR #1 —LAYER B:
(Star Points to Triangles)

Do 2 Rows — Single thread of GOLD DMC
 Metallic #282.

ENTER to EXIT below the last MELON Row.

Fig. 20

LAYER A

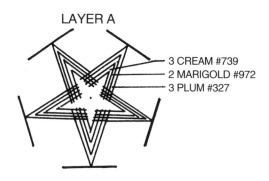

3 CREAM #739
2 MARIGOLD #972
3 PLUM #327

STAR #2 —LAYER A:
(Star Points to Sides)

ENTER to EXIT 3/4 out from CENTER.

Do 3 Rows of CREAM #739.
 2 Rows of MARIGOLD #972.
 3 Rows of PLUM #327.

EXTEND POINTS to Pentagon SIDES.

Fig. 21

LAYER B

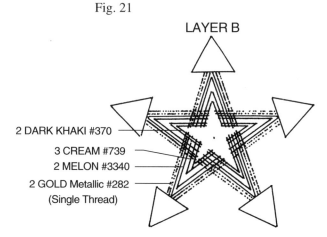

2 DARK KHAKI #370

3 CREAM #739

2 MELON #3340

2 GOLD Metallic #282
(Single Thread)

STAR #2 —LAYER B:
(Star Points to Triangles)

Do 2 Rows of DARK KHAKI #370.
 3 Rows of CREAM #739.
 2 Rows of MELON #3340.
 2 Rows — Single thread of GOLD Metallic #282.

Fig. 22

LAYER A

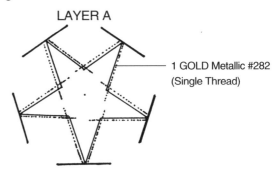

— 1 GOLD Metallic #282
(Single Thread)

STAR #2 —LAYER A:
(Star Points to Sides)

Do 1 Row — Single thread of GOLD Metallic #282.
Start OUTSIDE the PLUM ROWS.

Fig. 23 ## LAYER B

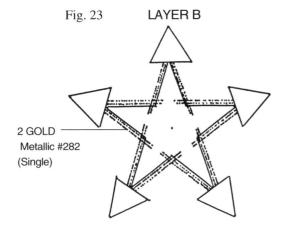

2 GOLD —
Metallic #282
(Single)

STAR #2 —LAYER B:
(Star Points to Triangles)

Do 2 Rows — Single thread of GOLD Metallic
#282.
Start OUTSIDE the MELON ROWS.

Fig. 24

LAYER A

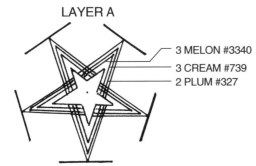

— 3 MELON #3340
— 3 CREAM #739
— 2 PLUM #327

STAR #3 —LAYER A:
(Star Points to Sides)

Do 3 Rows of MELON #3340.
 3 Rows of CREAM #739.
 2 Rows of PLUM #327.

Fig. 25 ## LAYER B

STAR #3 —LAYER B:
(Star Points to Triangles)

Do 3 Rows of PLUM #327.
 2 Rows of CREAM #739.
 1 Row of DARK KHAKI #370.
 2 Rows — Single thread of GOLD Metallic #282.

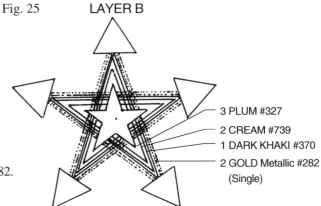

— 3 PLUM #327
— 2 CREAM #739
— 1 DARK KHAKI #370
— 2 GOLD Metallic #282
 (Single)

Fig. 26

LAYER A

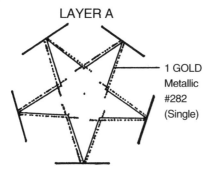

1 GOLD
Metallic
#282
(Single)

STAR #3 —LAYER A:
(Star Points to Sides)

Do 1 Row—Single thread of
 GOLD Metallic #282.

Fig. 27

LAYER A

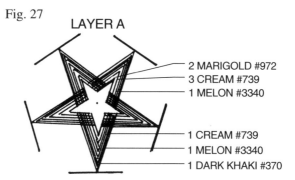

2 MARIGOLD #972
3 CREAM #739
1 MELON #3340

1 CREAM #739
1 MELON #3340
1 DARK KHAKI #370

STAR #4 —LAYER A:
(Star Points to Sides)

Do 2 Rows of MARIGOLD #972.
 3 Rows of CREAM #739.
 1 Row of MELON #3340.
 1 Row of CREAM #739.
 1 Row of MELON #3340.
 1 Row of DARK KHAKI #370.

Fig. 28

LAYER B

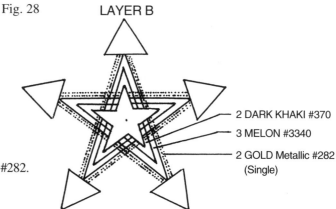

2 DARK KHAKI #370
3 MELON #3340
2 GOLD Metallic #282
(Single)

STAR #4 —LAYER B:
(Star Points to Triangles)

Do 2 Rows of DARK KHAKI #370.
 3 Rows of MELON #3340.
 2 Rows—Single thread of GOLD Metallic #282.

Fig. 29

LAYER A

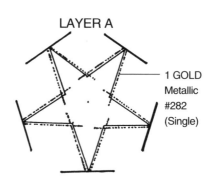

1 GOLD
Metallic
#282
(Single)

STAR #4 —LAYER A:
(Star Points to Sides)

Do 1 Row—Single thread of GOLD Metallic #282.

Fig. 30

LAYER A

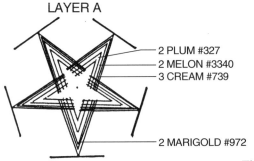

— 2 PLUM #327
— 2 MELON #3340
— 3 CREAM #739

— 2 MARIGOLD #972

STAR #5 —LAYER A:
(Star Points to Sides)

Do 2 Rows of PLUM #327.
 2 Rows of MELON #3340.
 3 Rows of CREAM #739.
 2 Rows of MARIGOLD #972.

Fig. 31

STAR #5 —LAYER B:
(Star Points to Triangles)

Do 2 Rows of MARIGOLD #972.
 2 Rows of CREAM #739.
 1 Row of MARIGOLD #972.
 1 Row of DARK KHAKI #370.

LAYER B

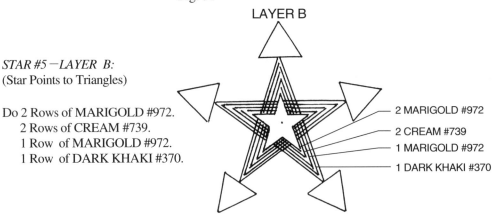

— 2 MARIGOLD #972
— 2 CREAM #739
— 1 MARIGOLD #972
— 1 DARK KHAKI #370

Fig. 32

LAYER A

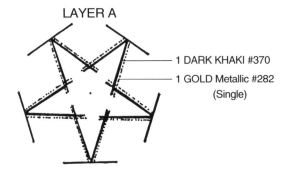

— 1 DARK KHAKI #370
— 1 GOLD Metallic #282
 (Single)

STAR #5 —LAYER A:
(Star Points to Sides)

Do 1 Row of DARK KHAKI #370.
 1 Row—Single thread of GOLD Metallic #282.

STAR #5 —LAYER B:
(Star Points to Triangles)

Do 1 Row of DARK KHAKI #370.
 1 Row—Single thread of GOLD Metallic #282.

Fig. 33

LAYER B

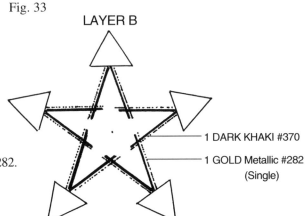

— 1 DARK KHAKI #370
— 1 GOLD Metallic #282
 (Single)

108

Fig. 34

LAYER A

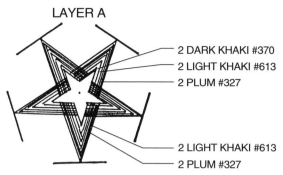

— 2 DARK KHAKI #370
— 2 LIGHT KHAKI #613
— 2 PLUM #327

— 2 LIGHT KHAKI #613
— 2 PLUM #327

STAR #6 —LAYER A:
(Star Points to Sides)

Do 2 Rows of DARK KHAKI #370.
 2 Rows of LIGHT KHAKI #613.
 2 Rows of PLUM #327.
 2 Rows of LIGHT KHAKI #613.
 2 Rows of PLUM #327.

Fig. 35

LAYER B

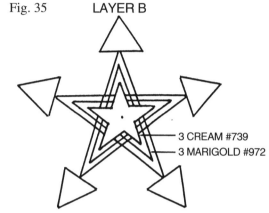

— 3 CREAM #739
— 3 MARIGOLD #972

STAR #6 —LAYER B:
(Star Points to Triangles)

Do 3 Rows of CREAM #739.
 3 Rows of MARIGOLD #972.

Fig. 36

LAYER A

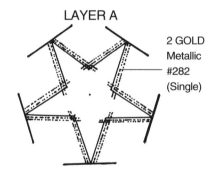

2 GOLD
Metallic
#282
(Single)

STAR #6 —LAYER A:
(Star Points to Sides)

Do 2 Rows — Single thread of GOLD Metallic #282
 outside the Plum.

STAR #6 —LAYER B:
(Star Points to Triangles)

Do 2 Rows — Single thread of GOLD Metallic #282
 outside the Marigold.

Complete CENTER STARS in ALL 12 Pentagon
Centers. REPEAT each pattern at its opposite
pentagon on the ball.

LAYER B

Fig. 37

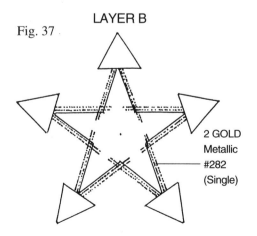

2 GOLD
Metallic
#282
(Single)

109

STAGE 3 — Pentagons (The Final Layers)

Each Center Star is OUTLINED with
PENTAGONS of several colors. Pentagons are
applied in LAYERS. ONE LAYER means
Pentagons of ONE COLOR. Each layer of color is
applied to all 12 Pentagons over the ENTIRE
BALL. The LAYERS create the pattern.
As Pentagons grow in size, their POINTS OVERLAP
to create Diamonds in between the Triangles.

Stitch a PENTAGON by CONNECTING the
POINTS OF THE STAR.

First use the star points with NO TRIANGLES.

CONNECT the POINTS of the Star with 1 ROW —
Single thread, of GOLD Metallic #282. There will
be space between the GOLD Row and the TRIANGLES.

Fig. 38

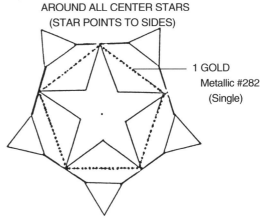

AROUND ALL CENTER STARS
(STAR POINTS TO SIDES)

1 GOLD
Metallic #282
(Single)

Fig. 39

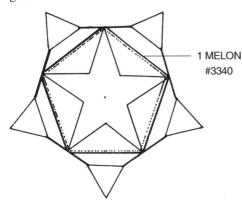

1 MELON
#3340

Do 1 ROW of GOLD around the NO-TRIANGLE
STAR POINTS of ALL 12 Center Stars.

Use 2 STRANDS of all of the DMC 6 strand
Embroidery Floss Colors.

With 2 STRANDS of the 6 strand floss, do 1 ROW
of MELON #3340 OUTSIDE the Gold Metallic
#282 rows ALL OVER the ball.

Pentagon layers will fill in the space between the
first Gold Row and triangles' sides.

The next Pentagon Points go OUTSIDE the GOLD
MARK LINES of the Pentagon Sides.
As the Pentagons grow in size, the points
OVERLAP to create DIAMONDS in between the
Triangles.

Each LAYER of COLOR COVERS the ENTIRE
BALL. The Layers create the pattern.
POINTS OF PENTAGONS CAN GO OVER
POINTS OF STARS.

LAYER 1: Do 1 Row of MARIGOLD #972
 (2 strands) around all 12 Pentagons.

Fig. 40

USE 2 STRANDS

Fig. 41 LAYER 1

PENTAGON
POINTS OVER
MARK LINES

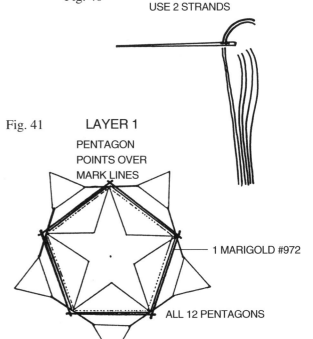

1 MARIGOLD #972

ALL 12 PENTAGONS

Fig. 42

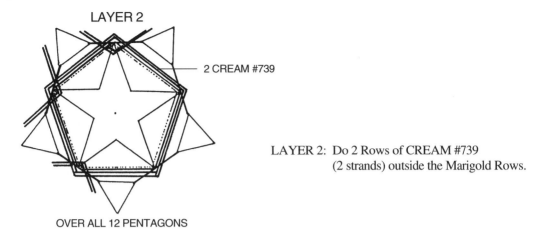

LAYER 2

2 CREAM #739

OVER ALL 12 PENTAGONS

LAYER 2: Do 2 Rows of CREAM #739
(2 strands) outside the Marigold Rows.

Fig. 43

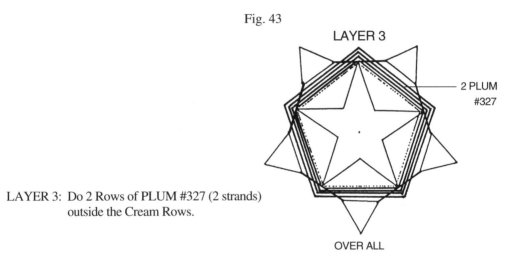

LAYER 3

2 PLUM
#327

OVER ALL

LAYER 3: Do 2 Rows of PLUM #327 (2 strands)
outside the Cream Rows.

Fig. 44

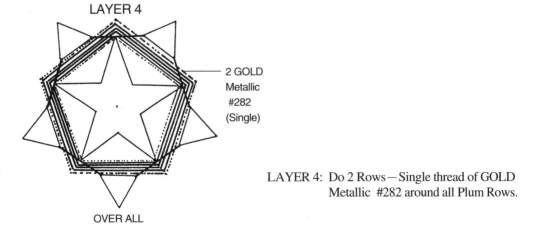

LAYER 4

2 GOLD
Metallic
#282
(Single)

OVER ALL

LAYER 4: Do 2 Rows — Single thread of GOLD
Metallic #282 around all Plum Rows.

The ball is complete.

111

Chapter 10

KOMA — Spinning Top Ornament

Koma is another ornament that is derived from a child's toy, originally a spinning top. The 3 sided double pyramid was probably originally carved from wood. This koma ornament begins with a cardboard inner structure that is wrapped with threads, yarns or narrow ribbons. The points of the koma are hung with small tassels in a coordinating color. A vast variety of materials can be used to decorate. It's a great children's project!

 4 sizes and color combinations are given, the first provides the instructions for the base structure, the remaining 3 designs follow, giving size-proportional patterns for base structure and list of pattern threads in order of application.

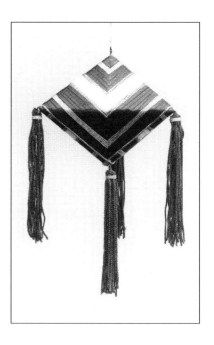

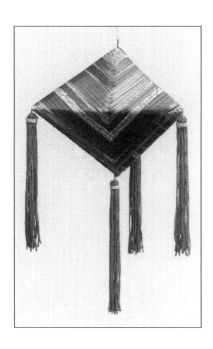

MATERIALS for the inner structure:

Cardboard—the weight of a cereal box
Scissors
Ruler (One foot)
Small T-square
Cellophane tape—double stick and regular
Sewing thread—black or clear (invisible)
Aleene's Tacky Glue—fast-drying white
 craft glue
Toothpicks or partly straightened paper clips

THE CARDBOARD INNER STRUCTURE:

Fig. 1

ACCURACY IS THE KEY TO EASE.
Careful measuring in the beginning will make later
progress simple.

2 pattern shapes for the Koma work equally well.
Choose one of the two pattern shapes.

Each of the SQUARES must be IDENTICAL in
SIZE in both patterns. CORNERS must be
ACCURATE 90 DEGREE ANGLES.
Use your T-SQUARE to measure and square the
corners.

Fig. 2

PATTERN 1

Fig. 3

PATTERN 2

The patterns may be made in any size, from tiny to
huge, if they use proportionally-sized materials.

For this pattern, a 3-inch square will be used.

DRAW ALL LINES on the pattern before you
begin to cut.

Measure carefully and CUT ACCURATELY
around the OUTSIDE of the pattern.

NOW READ THROUGH THE INSTRUCTIONS
BEFORE YOU CONTINUE.

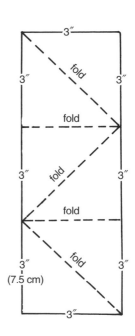

With your ruler and one blade of your scissors, SCORE the cardboard along the DOTTED FOLD LINES.
There are 5 FOLD LINES to score in whichever pattern you select.

TO SCORE: Hold your ruler alongside the dotted fold line. Use one blade of the scissors to press a dent along the ruler on the fold line.
Go over each line TWICE. DO NOT CUT ALL THE WAY THROUGH.
Scoring the cardboard makes a straight and accurate fold that is easy to control.

Fig. 4

SCORE THE FOLD LINES

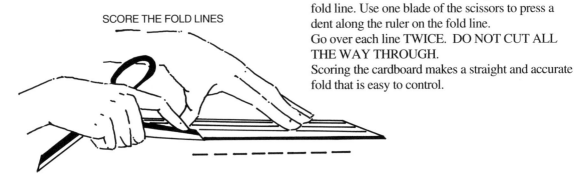

Fig. 5

BE SURE THAT SCORED LINES ARE DRAWN ACCURATELY INTO THE POINTS AND CORNERS of the pattern.

BEND the cardboard AWAY FROM the SCORE on all of the score lines so that the flat pattern turns into a pyramid-shaped box.

Fig. 6

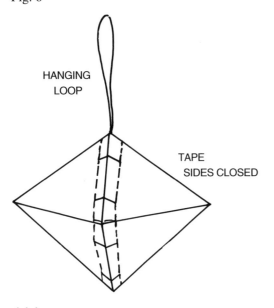

HANGING LOOP

TAPE SIDES CLOSED

Before you close the box, make a LOOP of SEWING THREAD that is 3 inches in length when doubled. KNOT the 2 ends together and tape the knotted end to the inside of the cardboard so the loop comes out of the TOP POINT. This is your hanging loop.

On the outside, use double-stick tape to carefully tape the box closed with the loop on the outside. The tape won't show, it will be covered by the ribbons and will help hold them in place.

MATCH the SIDES carefully.
Make the CORNERS sharply pointed.

114

WRAPPING THE KOMA

MATERIALS:

Cardboard pyramid box
Aleene's Tacky Glue
Small saucer for glue
Toothpicks or unbent paper clips
Scissors
1/8 inch wide ribbon in 3 colors:
 Dark Green - Satin (4 1/2 yds)
 Dark Red - Satin (4 1/2 yds)
 White - Grosgrain (1 1/2 yds)
 (Small spools of ribbon found in crafts stores
 contain about 6 to 10 yards of ribbon,
 Offray or other).
 1 yard of material wraps approximately 2 rows
Metallic Gold — Kreinik's Balger Medium Braid
 #16 — #002J
Metallic Gold 1/16 inch Craft Braid — heavier cord
 texture (3 yds or 1 small spool)
4 inch Fringe in 2 colors:
 Dark Green (1/3 yd)
 Dark Red (1/8 yd)
1/8 inch GOLD Woven Ribbon (1/2 yd)

Fig. 7

UNBENT
PAPER CLIPS

Fig. 8

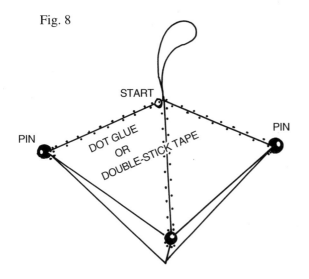

START

PIN

PIN

DOT GLUE
OR
DOUBLE-STICK TAPE

To begin, place a glass-headed pin in the TIP of each POINT of the Koma.

Use double-stick tape or, with a toothpick, DOT a little GLUE along both sides of the TOP EDGES and UNDER EACH PIN.

Start with the DARK GREEN 1/8 inch ribbon.

115

Lay the first row of GREEN Ribbon on the LEFT SIDE of one edge. Start at the TOP next to the hanging loop. The EDGE of the Ribbon should lay RIGHT ALONG the EDGE of the pyramid.

THE FIRST ROW IS IMPORTANT. KEEP THIS FIRST ROW CLOSE TO THE UPPER EDGES AND OUT TO THE FURTHEST POINT POSSIBLE UNDER EACH TIP.
The pin will keep it from sliding off.

Fig. 9

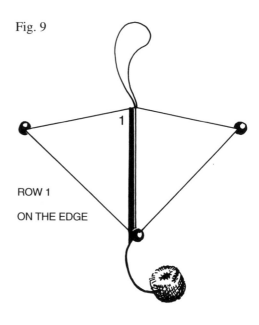

ROW 1

ON THE EDGE

Fig. 10

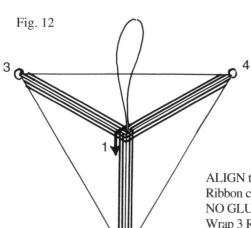

START 1

2

Beginning at the NUMBER 1, wrap down the LEFT EDGE, UNDER the KOMA'S POINT (and pin) at the NUMBER 2, back up the RIGHT EDGE to the TOP.

Fig. 11

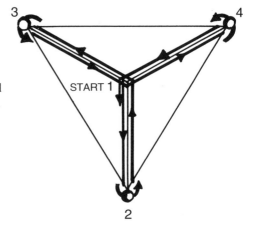

START 1

3

4

2

Go PAST the hanging loop to the NUMBER 3. Go UNDER the POINT and back up to the TOP, pass the hanging loop and over to NUMBER 4 and UNDER ITS POINT. Then back to the Beginning.

Fig. 12

3 4

1

2

ALIGN the SECOND ROW of DARK GREEN Ribbon closely alongside the first row.
NO GLUE IS NEEDED. Follow the same directions.
Wrap 3 ROWS of DARK GREEN 1/8 inch Satin Ribbon.

END where you BEGAN.

TO END:

Apply a DOT of glue at the POINT of the
SQUARE THAT IS FORMED.
Pull the ribbon firmly across the Koma so it is tight
across the surface.
Measure the thread to END at the DOT of glue plus
1/4 inch extra. CUT the ribbon and PRESS IT into
the glue. Hold it in place for a few seconds until it
sticks.

Fig. 13

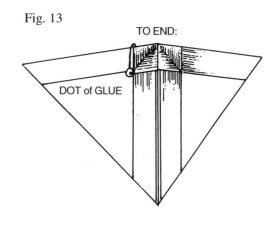

TO END:

DOT of GLUE

Fig. 14

ATTACH
the NEXT COLOR

BEGIN & END
in the SAME CORNER,
SAME SIDE EACH TIME.

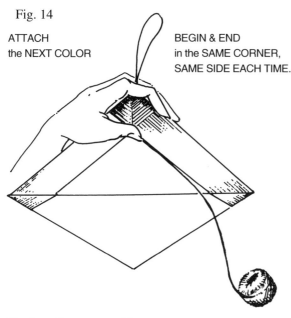

As it is drying, ATTACH the NEXT COLOR with
a DOT of glue on top of the end.

NEXT COLOR is GOLD Kreinik's Balger
Medium Braid #16.

ATTACH to where the last row ended. Hold both
in place until they are stuck.

As you wrap the Koma, keep threads aligned
closely next to one another.
Wrap the threads tightly onto the base but carefully
so that the box does not bend with the tension.
END where you BEGAN.

Continue the pattern with

4 Rows of GOLD Kreinik Medium Braid #16.
4 Rows of DARK RED 1/8 inch SATIN RIBBON.
2 Rows of GOLD CRAFT BRAID.
3 Rows of WHITE 1/8 inch Grosgrain Ribbon.
2 Rows of GOLD CRAFT BRAID.
5 Rows of DARK GREEN 1/8 inch Satin Ribbon.
4 Rows of GOLD Kreinik Balger Medium Braid
 #16.
3 Rows of DARK RED 1/8 inch Satin Ribbon.
1 Row of GOLD CRAFT BRAID.

Fig. 15

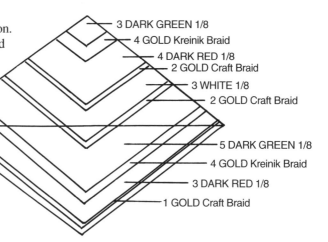

3 DARK GREEN 1/8
4 GOLD Kreinik Braid
4 DARK RED 1/8
2 GOLD Craft Braid
3 WHITE 1/8
2 GOLD Craft Braid
5 DARK GREEN 1/8
4 GOLD Kreinik Braid
3 DARK RED 1/8
1 GOLD Craft Braid

Fig. 16

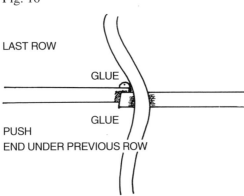

LAST ROW

GLUE

GLUE

PUSH
END UNDER PREVIOUS ROW

END the LAST ROW by cutting 1/4 inch extra cord. Push a DOT of glue UP UNDER the threads. Push the extra thread UP UNDER the wrapped threads and INTO the glue. Hold in place until the glue sticks.

The Koma is complete, but this ornament traditionally has four tassels hanging from its points. For this Koma, a DARK RED TASSEL hangs from the Bottom, 3 DARK GREEN TASSELS hang from the Side Points.

Turn to the next chapter for instructions on how to make these simple tassels.

3 MORE KOMA COMBINATIONS — Different Sizes and Different Colors

1. RED, BLUE, GREEN and GOLD — 3 1/4-inch KOMA

MATERIALS:

1/8 inch Satin Ribbon in 3 colors:
 Red (3 yds)
 Green (4 yds)
 Blue (4 yds)
 or one small spool of each color, Offray or other — 6 to 10 yards per spool
GOLD novelty yarn — Rainbow Galleries "Gold Rush 12" — 2 cards 10 yds each
 or Kreinik's Balger Medium Braid #16 (Gold #002J) 2 spools
GOLD 1/8 inch Woven Ribbon (1 1/2 yds)
BRIGHT RED 4 inch Fringe (1/3 yd)

Fig. 17

PATTERN 1

3 1/4″ 3 1/4″

3 1/4″
(8 cm)

3 1/4″

3 1/4″

Fig. 18

PATTERN 2

3 1/4″

3 1/4″

3 1/4″

3 1/4″

3 1/4″
(8 cm)

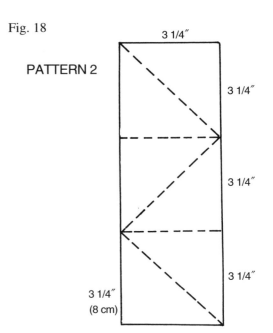

Fig. 19

RED, GREEN, BLUE, GOLD KOMA

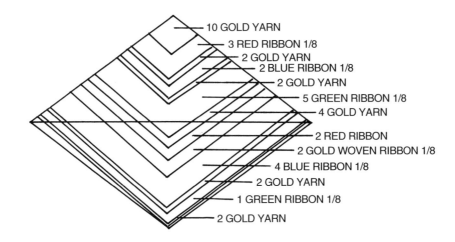

- 10 GOLD YARN
- 3 RED RIBBON 1/8
- 2 GOLD YARN
- 2 BLUE RIBBON 1/8
- 2 GOLD YARN
- 5 GREEN RIBBON 1/8
- 4 GOLD YARN
- 2 RED RIBBON
- 2 GOLD WOVEN RIBBON 1/8
- 4 BLUE RIBBON 1/8
- 2 GOLD YARN
- 1 GREEN RIBBON 1/8
- 2 GOLD YARN

THE PATTERN:

10 Rows — GOLD NOVELTY YARN "Gold Rush"
 or Balger Medium Braid
3 Rows — RED 1/8 inch Satin Ribbon
2 Rows — GOLD NOVELTY YARN — "Gold Rush"
 or Balger Medium Braid
2 Rows — BLUE 1/8 inch Satin Ribbon
2 Rows — GOLD NOVELTY YARN — "Gold Rush"
 or Balger Medium Braid
5 Rows — GREEN 1/8 inch Satin Ribbon
4 Rows — GOLD NOVELTY YARN — "Gold Rush"
 or Balger Medium Braid
2 Rows — RED 1/8 inch Satin Ribbon
2 Rows — GOLD 1/8 inch Woven Ribbon
4 Rows — BLUE 1/8 inch Satin Ribbon
2 Rows — GOLD NOVELTY YARN — "Gold Rush"
 or Balger Medium Braid
1 Row — GREEN 1/8 inch Satin Ribbon
2 Rows — GOLD NOVELTY YARN — "Gold Rush"
 or Balger Medium Braid.

The Koma is complete.

Make 4 BRIGHT RED TASSELS from 4 inch fringe.
Wrap the TOP of each with GOLD WOVEN RIBBON.

2. AQUA BLUE, ROYAL BLUE, YELLOW — 2 1/2-inch KOMA

MATERIALS:

1/8 inch Satin Ribbon in 3 colors:

 Aqua Blue (3 yds)

 Bright Yellow (2 yds)

 Turquoise Blue (2 yds), darker than Aqua Blue

1/16 inch Satin Ribbon in 2 colors:

 Bright Orange (2 yds)

 Metallic Royal Blue — 1 spool — Kreinik's

 Woven Ribbon #033

 or Rhode Island Textiles #16 Deep Blue

 Metallic Floss

Silver Braid — Kreinik's Balger Medium Braid #16

 (color #001J) — 1 spool

Royal Blue 4 inch Fringe — 1/3 yd

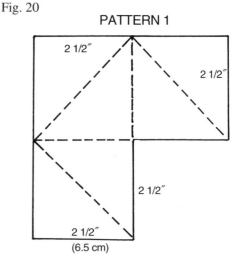

Fig. 20

PATTERN 1

Fig. 21

PATTERN 2

THE PATTERN:

 3 Rows — AQUA BLUE 1/8 inch Satin Ribbon
 4 Rows — SILVER BRAID — Balger (#001J)
 Medium Braid #16
 1 Row — ORANGE 1/16 inch Satin Ribbon
 3 Rows — METALLIC ROYAL BLUE 1/16
 Woven Ribbon
 1 Row — ORANGE 1/16 inch Satin Ribbon
 3 Rows — YELLOW 1/8 inch Satin Ribbon
 4 Rows — SILVER BRAID — Balger (#001J)
 Medium Braid #16
 2 Rows — TURQUOISE 1/8 inch Satin Ribbon
 2 Rows — ORANGE 1/16 inch Satin Ribbon
 3 Rows — METALLIC ROYAL BLUE 1/16
 Woven Ribbon
 2 Rows — AQUA BLUE 1/8 inch Satin Ribbon.

Fig. 22

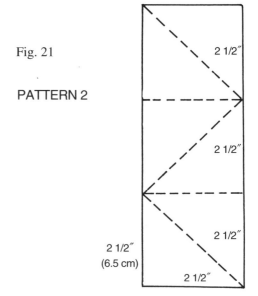

3 AQUA BLUE RIBBON 1/8
4 SILVER BRAID
1 ORANGE RIBBON 1/16
3 METALLIC BLUE 1/16
1 ORANGE 1/16
3 YELLOW 1/8
4 SILVER BRAID
2 TURQUOISE 1/8
2 ORANGE 1/16
3 METALLIC BLUE 1/16
2 AQUA BLUE 1/8

The Koma is complete.

Make 4 TASSELS from 4 inch Royal Blue Fringe.
Wrap each tassel at the top with SILVER BRAID —
Balger Medium Braid #16.

3. PURPLE, AQUA BLUE — 2-inch KOMA

MATERIALS:

1/16 inch Satin Ribbon in 3 Colors:
 Purple (6 yds)
 Metallic Royal Blue — Kreinik #033 Deep Blue
 or Rhode Islands Textiles #16 Deep Blue (4 yds)
 Orange (1 yd)
1/8 inch Satin Ribbon — Aqua Blue (2 yds)
Gold Braid — Kreinik's Balger Medium Braid #16
 (color 002J) remainder from previous Komas
 (2 yds)

FOR TASSELS:

GOLD Machine Embroidery Thread — 1 spool
GOLD 1/8 inch Woven Ribbon (1/4 yd)

THE PATTERN:

 5 Rows — PURPLE 1/16 inch Satin Ribbon
 2 Rows — GOLD BRAID (002J) Balger Medium Braid #16
 1 Row — AQUA BLUE 1/8 inch Satin Ribbon
 4 Rows — METALLIC ROYAL BLUE 1/16 inch Ribbon
 1 Row — ORANGE 1/16 inch Satin Ribbon
 2 Rows — PURPLE 1/16 inch Satin Ribbon
 2 Rows — AQUA BLUE 1/8 inch Satin Ribbon
 3 Rows — METALLIC ROYAL BLUE 1/16 inch Ribbon
 3 Rows — PURPLE 1/16 inch Satin Ribbon
 1 Row — GOLD BRAID (002J) Balger Medium
 Braid #16.

Fig. 23

PATTERN 1

2″ 2″

2″

2″

2″

2″
(5 cm)

Fig. 24

PATTERN 2

2″

2″ 2″

2″

2″
(5 cm)

2″

2″

The Koma is complete.

Make 4 GOLD TASSELS from the
Gold Machine Embroidery thread,
each tassel 2 inches long. Wrap the top of each
with GOLD WOVEN RIBBON (002J).
These tassels are hand made. The GOLD thread is
wrapped around a 2-inch cardboard card. The top
end is tied tightly and knotted with the same thread.
(See instructions for large tassels with the Dragonfly Knot).

Fig. 25

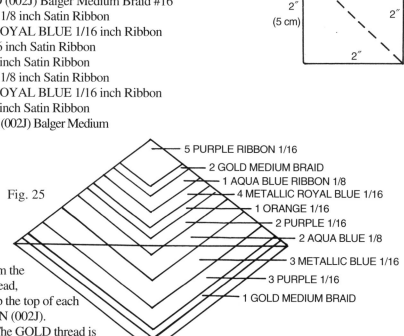

5 PURPLE RIBBON 1/16
2 GOLD MEDIUM BRAID
1 AQUA BLUE RIBBON 1/8
4 METALLIC ROYAL BLUE 1/16
1 ORANGE 1/16
2 PURPLE 1/16
2 AQUA BLUE 1/8
3 METALLIC BLUE 1/16
3 PURPLE 1/16
1 GOLD MEDIUM BRAID

Chapter 11
TASSELS and DRAGONFLY KNOT

Silky tassels add a festive and formal touch to both Koma and Temari. Traditionally, when a Temari is given as an "auspicious gift," the ball has hanging from the bottom a large dragonfly knot with two long, luxuriant tassels attached to the ends.

Here is a simple method of making tassels from decorative upholstery fringe. It is made of the same material as Japanese Bunka thread tassels but it is stitched across the top. Available in larger fabric stores and craft centers, this fringe comes in several lengths. 4- and 6-inch fringes should be used for the Koma and 3-inch Temari.

For 4-inch Temari, longer tassels are used, up to 12 inches in length, plus a gold cord dragonfly knot. Included at the end of this chapter are instructions for the dragonfly knot used with Bunka thread (Japanese rayon chainette tassel material). Short tassels on large Temari are not appropriate because the size and proportion are incorrect. Tassels can also be made from DMC Pearl Cotton #5 if fringe and Bunka thread are not available.

TASSELS

MATERIALS:
(for the KOMA in the previous chapter)
1/8 yard each of 4-inch fringe:
> Dark Red (Maroon)
> Dark Green (Forest Green)
> Bright Red
> Royal Blue

1/8 yard of 6-inch fringe (for bottom points only —
> there is sufficient in the amounts given of 4-inch
> fringe to include this if your store doesn't carry 6-
> inch length)
> (EACH TASSEL TAKES ABOUT 1 1/2 INCHES
> OF FRINGE)

1/8 yard of GOLD 1/8 inch Wide Ribbon (Kreinik's
> Balger #002J)

Aleene's Tacky Glue

Scissors for cutting fringe

Toothpicks or straightened paper clips

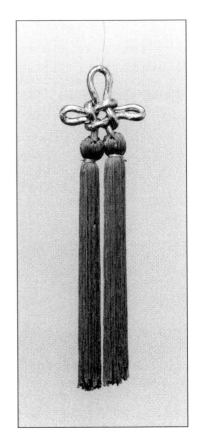

THE 6-inch TASSEL is for THE BOTTOM
POINT OF THE KOMA.

Fig. 1

SPREAD the 6-inch fringe FLAT.
Count over 6 LOOPS across the top stitching.
CUT after loop 6. This length measures about
1 1/2 inches.

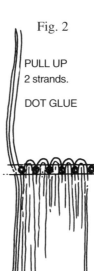

1 1/2 inch

1 2 3 4 5 6

Gently PULL UP the first 2 strands out of the
FIRST LOOP and straighten into a VERTICAL
LINE.
DOT GLUE along the loops in between the rows of
stitching.
Hold the 2 VERTICAL STRANDS up and out of
the way.

Fig. 2

PULL UP
2 strands.

DOT GLUE

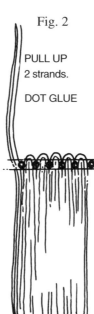

Fig. 3

WITH STRANDS
OUT OF CENTER,
ROLL IT UP.

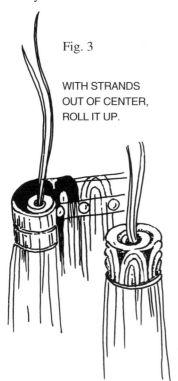

Starting at the side with the 2 VERTICAL
STRANDS, tightly ROLL UP the fringe at the
glued end so that the first 2 strands project out the
top. Use a paper clip or tooth pick to help you roll.

Squeeze the top together tightly.
Keep it ROUND.

Fig. 4

If the top end is neat, you need not wrap over it with
a vertical strand.

If the top end comes out looking rough, use one of
the 2 vertical strands to wrap around the outside.
This will disguise any loose threads.
To do this, cover the loop end with glue.
Wrap one of the vertical strand over the top end.
Press it tightly into place.
Push the strand end up under the last wrap.

USE 1 STRAND
TO FINISH TOP

OR CUT IT OFF.

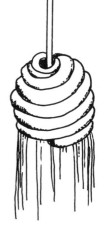

123

Fig. 5

DECORATE the tassel by gluing a piece of 1/8 inch GOLD Ribbon around the neck of the tassel.
- Apply a thin line of glue just below the loops.
- BEFORE YOU CUT THE RIBBON, wrap it around the tassel to MEASURE WITH 1/4 INCH EXTRA.
- Dot glue under the overlap.
- Pull the Ribbon around tightly, press it down, cut off the excess.

1/8 inch
GOLD
RIBBON

If you have NOT covered the top with one of the 2 strings, CUT 1 OFF at the tassel, only 1 is needed. LEAVE ONE THREAD COMING OUT OF THE TASSEL.

The tassel is complete.

Make 3 MORE TASSELS for the 3 SIDE POINTS of the Koma. Use the 4-inch fringe.

ATTACHING the TASSELS to the KOMA:

Tie a SINGLE KNOT on the one remaining string, 1/2 INCH ABOVE the tassel. Pull the knot tight.

Fig. 6

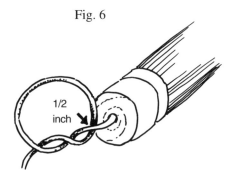

1/2 inch

Fig. 7

1/2 inch

1/2 inch

KNOT

CUT OFF the string 1/2 inch ABOVE the knot.

Take your Koma. Remove the Corner Pins. Be careful not to let the end threads slip off.

Fig. 8

Use your paper clip to poke a hole at the TIP of each POINT where the pins were located.

Widen the hole slightly by swiveling the paper clip around in a circle.
Make the hole just wide enough to push the knot on the tassel through.

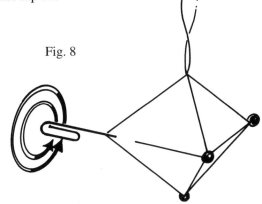

Fig. 9

Lay the tassel string onto the corner of the Koma
SO THE KNOT LIES OVER THE HOLE.

With your paper clip, carefully PUSH the KNOT
THROUGH THE HOLE to the inside of the Koma.
Push the excess length of string inside as well.

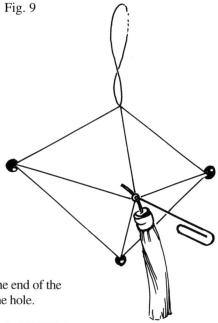

Take a small amount of GLUE on the end of the
paper clip. PUSH GLUE INSIDE the hole.

Fig. 10

With your thumb and forefinger, gently PINCH the
HOLE CLOSED with one hand. Other hand gently
pulls the tassel cord until the KNOT SINKS INTO
THE GLUE on the inside.

REPEAT on the remaining side points and then on
the bottom.

The Koma is complete.

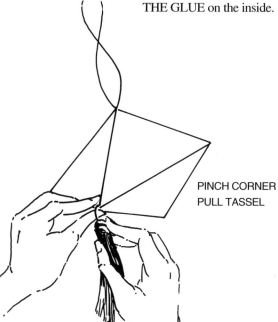

PINCH CORNER
PULL TASSEL

TASSELS FOR TEMARI are tacked onto the ball
with a needle and thread, or, for temporary, pinned
onto the ball with a straight pin.

Use one or both vertical strings to tie a KNOT 1/2
INCH ABOVE THE TASSEL.
Pull the knot tight.
Cut of excess string above the knot.
Put a dot of GLUE AROUND THE KNOT to keep
from raveling.
Either push a pin through the knot and into the ball
or Stitch to the ball with the same thread wrap color.

125

PLACING the TASSEL onto the BALL:

Balls with an Obi line are often displayed more effectively if they are hung with the OBI running VERTICALLY around the ball (up and down). This shows both sides of the design as well as the Obi.

Balls with a symmetrical design display tassels at the their regular SOUTH POLE.

Consider the totality of the design when placing the tassel.

Fig. 11

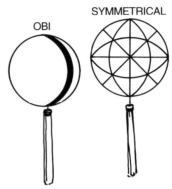

Fig. 12

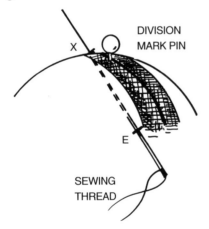

HANGING LOOP:

A hanging loop may be stitched to the ball at the opposite end from the tassel. Check division lines to make sure placement is accurate.

Use regular or invisible SEWING THREAD.

If the bottom ends of the loop are spread apart where they come out of the ball, the ball will hang straight forward and not spin.

Thread your needle with about 12 inches of sewing thread. KNOT the END.

ENTER the needle at the Obi Line, 1/2 inch to the RIGHT of a DIVISION MARK PIN.
Sink the needle deep into the ball. EXIT the needle 1/2 inch to the LEFT of the Division Mark Pin at the Obi Line.

Pull the knot through so that it disappears beneath the ball's surface.

Fig. 13

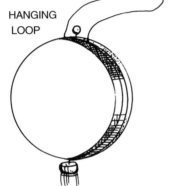

Take a TACK STITCH at the EXIT.

Allow a 4 to 5 inch LOOP of thread at the TOP of the ball.

Take a TACK STITCH or two on the other side of the Division Mark Pin where you ENTER.

ESCAPE the needle under the ball's surface.

Cut the thread.

Fig. 14

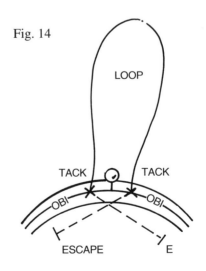

DRAGONFLY KNOT

On large balls—generally four inches in diameter and over, often a large dragonfly knot of gold or silver heavy cord with two long tassels hangs from the bottom. The two tassels, 8 to 12 inches in length, can be of 1 or 2 colors.

MATERIALS:

18 inches of heavy cord—1/4 inch diameter,
 Metallic GOLD or SILVER
Cellophane Tape
Scissors

Fig. 15

TYING THE DRAGONFLY KNOT:

Start by holding the first 4 inches of cord in your LEFT HAND.
Use the diagrams as your guide for the correct size.

With your RIGHT HAND, make the knot following Figures 15 through 20.

Fig. 16

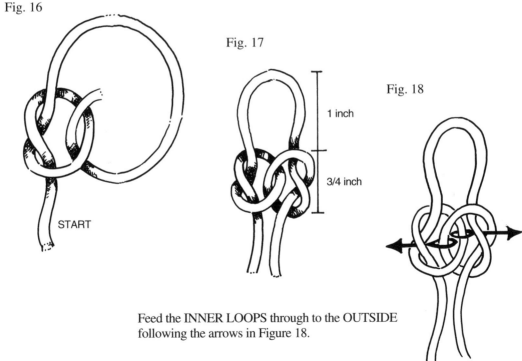

START

Fig. 17

1 inch

3/4 inch

Fig. 18

Feed the INNER LOOPS through to the OUTSIDE following the arrows in Figure 18.

Fig. 19

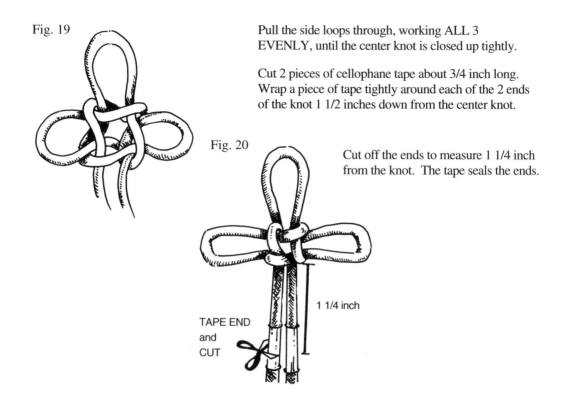

Pull the side loops through, working ALL 3 EVENLY, until the center knot is closed up tightly.

Cut 2 pieces of cellophane tape about 3/4 inch long. Wrap a piece of tape tightly around each of the 2 ends of the knot 1 1/2 inches down from the center knot.

Fig. 20

Cut off the ends to measure 1 1/4 inch from the knot. The tape seals the ends.

1 1/4 inch

TAPE END
and
CUT

TO MAKE the TASSELS for the DRAGONFLY KNOT

MATERIALS:

1 piece of stiff cardboard or wood the desired length
 of the tassels
 (8 to 10 inches long, 4 to 6 inches wide)
Bunka thread in 1 or 2 colors — 15 yards per tassel
 (DMC Pearl Cotton #5 may be used)
Gold or Silver Marking Thread
Scissors
Aleene's Tacky Glue
The Dragonfly Knot

Fig. 21

START

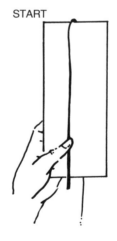

Fig. 22

25~30 WRAPS

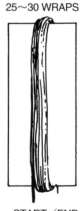

START／END

Begin by holding the Bunka thread's end at the BOTTOM of the cardboard with the thumb of the LEFT HAND.

WRAP the thread LENGTHWISE around the cardboard 25 to 30 times.
END AT THE BOTTOM.

Cut another piece of Bunka thread 12 inches long.
Slide it UNDER ALL of the threads at the TOP
EDGE OF THE CARDBOARD catching all.
Tie a DOUBLE GRANNY KNOT around all of the
threads. Pull it tight.

With scissors, CUT THROUGH ALL of the threads
at the BOTTOM of the cardboard so ends hang free.

Fig. 23

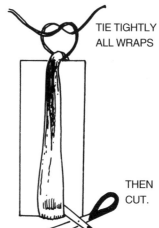

TIE TIGHTLY
ALL WRAPS

THEN
CUT.

Take the Dragonfly Knot. Apply GLUE to ONE END,
from the tip to 1/2 inch up, all the way around.

Fig. 24

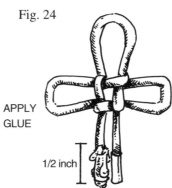

APPLY
GLUE

1/2 inch

Fig. 25

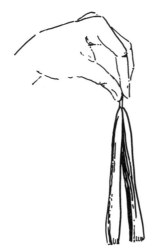

Hold the tassel by the Granny Knot with the threads
hanging down. SPLIT the thread into 2 parts.

Fig. 26

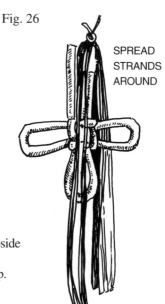

SPREAD
STRANDS
AROUND

Turn the Dragonfly Knot UPSIDE DOWN.
Attach the tassel to the GLUEY TIP of the upside
down Dragonfly Knot.
SPREAD the strands EVENLY around the tip.
PRESS the strands into the glue.

Cut another 12 inch piece of Bunka thread.
Tie with a Granny Knot 3/4 inch from the end.
Wrap the thread 2 to 3 times around and tie again
securely.

Fig. 27

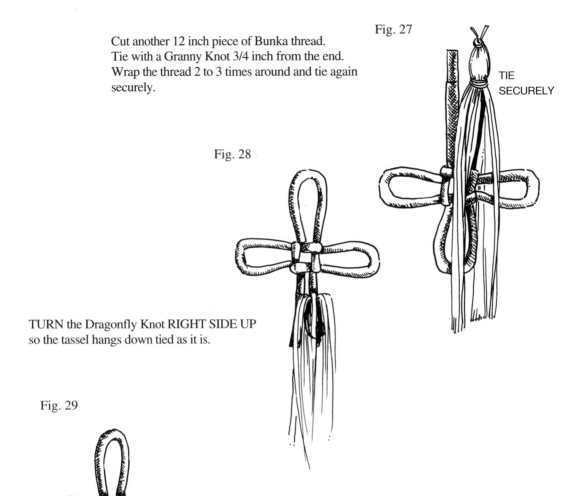

TIE
SECURELY

Fig. 28

TURN the Dragonfly Knot RIGHT SIDE UP
so the tassel hangs down tied as it is.

Fig. 29

TIE SECURELY with
GOLD THREAD

CUT 12 INCHES of GOLD Metallic marking
thread. Knot both ends to prevent raveling.

TIE the GOLD thread around the outside of the
tassel about 1/4 INCH UP FROM THE BOTTOM
of the Dragonfly end (inside the tassel).
Tie a Granny Knot, wrap it 2 to 3 times, then tie
another knot. Pull it tight. Cut the ends down close
to the tassel.

Fig. 30

REPEAT the steps for the second tassel on the other
Dragonfly end.

ATTACH the Dragonfly Knot to the ball by its TOP
LOOP with 2 to 3 tack stitches.

The Dragonfly Knot is complete.

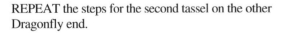